A FIELD GUIDE TO
BIRD
PHOTOGRAPHY

A FIELD GUIDE TO
BIRD
PHOTOGRAPHY

Steve Young

GUILD OF MASTER CRAFTSMAN PUBLICATIONS

First published 2002 by
Guild of Master Craftsman Publications Ltd,
166 High Street, Lewes,
East Sussex, BN7 1XN

Text and photographs © Steve Young
Copyright in the Work © Guild of Master Craftsman Publications Ltd

ISBN 1 86108 252 5

A catalogue record of this book is available from the British Library.

Cover design by Ian Smith of GMC Publications Design Studio
Book design by Phil and Traci Morash of Fineline Studios
Author photo courtesy of RJ Nason

Typeface: Rotis Semi sans

Colour origination by Viscan Graphics (Singapore)

Printed in Hong Kong by H & Y Printing Ltd

Contents

Acknowledgements

As a bird photographer, I am indebted to a lot of people for their time and information about where to find the birds that I photograph. We can all visit our local park and nature reserve, but after that, building contacts is the only way to get shots of a greater variety of species.

I owe a great many thanks to David Tipling for the use of his private site for much of my feeding station photography. Thank you David, it is always great fun! Thanks to Hannah and Graham for organizing my own 'bird café' in Lancashire, and to Andy McWilliam for allowing access to the educational hide near my home in Liverpool. Thanks to Steve White, warden at Seaforth Nature Reserve, who has made numerous calls to me over the years, and I have probably used more rolls of film there than anywhere else in the world! Thanks also to fellow wardens Pete Alker and Dominic Rigby for the assistance given at their reserves.

A special mention to Pete, Tony, Chris and Graham, who have been on countless trips with me to see so many species since the early 1980s, for their endless patience while I snap away for hours after they have finished watching the birds.

To the photographers on the Isles of Scilly with whom I share a 'home' each year in October. Thanks for all the hours spent talking f-stops, shutter speeds, cameras, lenses and the perfect photograph – we are still waiting to take it! So, keep trying George, David, Jack and Roger. To all the other Scilly regulars, especially Bryan, 'Spider' and JoJo, Martin, Amanda, Will, Becca, Mike and Flinty: thanks, it wouldn't be the same without you.

Finally, thank you to April McCroskie at GMC for commissioning this book, Kylie Johnston for bullying (!) me to finish it on time, and to designers Phil and Traci Morash at Fineline Studios for again turning my photos and words into a much better-looking book than I could imagine.

Jay
500mm lens, 1/60sec at f4

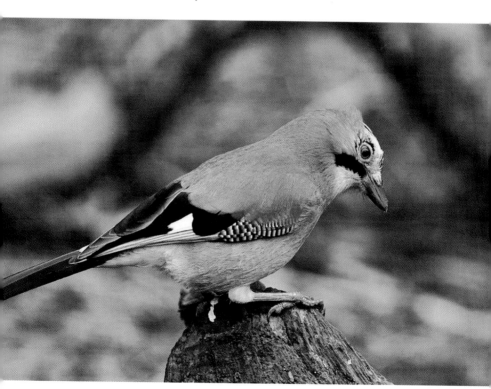

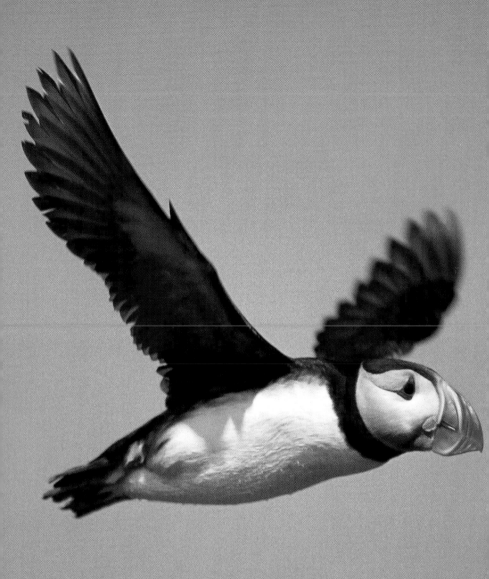

An all-consuming passion

Can there be a more enjoyable, rewarding – and frustrating – hobby than bird photography? Is it really worth the hours and hours of waiting patiently, more often than not for the moment that doesn't happen, lots of time spent looking at nothing, and sometimes only taking a poor record shot. The answer, of course, is a resounding yes, because occasionally – just every now and then – the chance comes along to capture that special moment on film. And when the photographer takes that chance and sees the resultant image, all the wasted hours and bad shots are instantly forgotten.

For the last twenty years or so, I have been trying to capture that moment and tomorrow, I will probably go out and try again. Along the way, I've made every conceivable mistake there is and still make plenty now, but thankfully nobody ever sees them. All the information in this field guide has come from my own experience over the years; finding out what did and did not work as I went along. Time spent with other bird photographers has also been invaluable, both for the shared knowledge and the fun we've had together. It is reassuring to realize that all photographers make the same mistakes and have the same worries about exposures.

In the beginning, my photography involved simply recording birds that I discovered as a birdwatcher, but developed into an

Flight shots are about the most difficult of bird photographs to take, but it is worth persisting with the technique for some spectacular results.

Puffin
500mm lens, 1/1500sec at f5.6

all-consuming passion. From taking poor-quality black-and-white snaps with much-used second-hand equipment, I progressed to good-quality cameras and lenses, more proficient techniques and better pictures. I read every book I could find on the subject and kept records of every exposure I made to improve on what was wrong. Patience was as important as the equipment I used, and I soon learnt that without it I wasn't going to get very far. This quality continues to be one of the key factors in taking great bird photographs out in the field.

This book is intended as a practical, pocket-sized companion volume to the *Essential Guide to Bird Photography* (also published by GMC Publications). Many of the subjects that I outline here are covered in greater depth in that publication. This guide is designed to be of everyday, practical help to you out in the field. You can use the notebook section at the back to keep details of your exposures until you are familiar with your camera and its settings. And you can consult the information and advice throughout to help you make on-the-spot decisions and to avoid making the same mistakes that I – and many others – have made before you.

However you want to use this book – whether to help you take shots of birds that you see in the field, or to specialize in bird photography rather than birdwatching – I hope this guide will be of real, practical value and enhance your enjoyment of being out in the field.

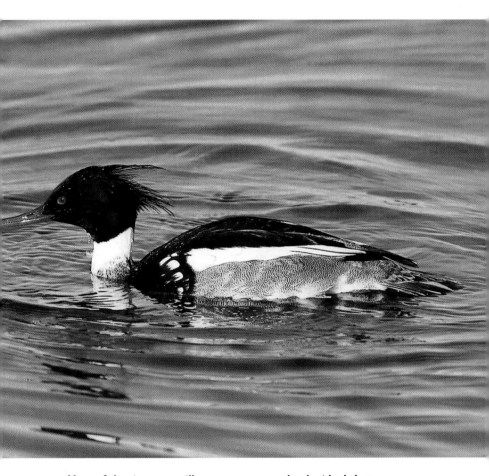

Most of the time you will not manage to take the ideal shot, but when everything comes together – the pose, the light, correct metering, the sharpness of the final result – it is worth all the effort. There is great satisfaction in knowing that you have captured the image.

Red-breasted Merganser
500mm lens, 1/250sec at f8

Equipment

My basic gear

Over the past twenty years, I have owned a variety of lenses and camera bodies and have taken both good and bad photos with them. I have tried just about every brand and speed of film available and have been amazed and appalled

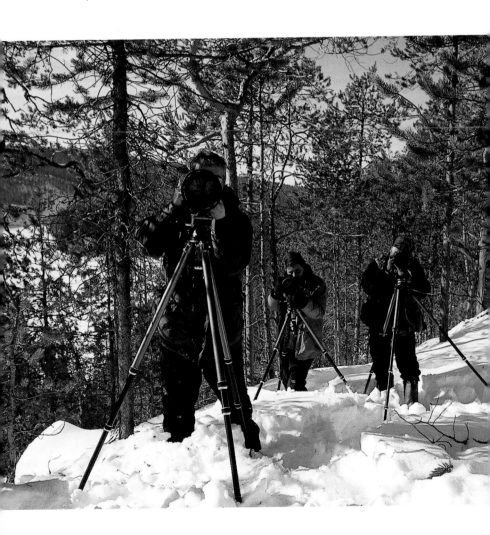

at some of the results. I now use Nikon camera equipment and Fuji film; Sensia 100 for my transparency work and either Superia 400 or 800 negative film when I specifically want to take prints.

All the photographs in this book were taken using either a Nikon F4 or F5 in conjunction with various lenses and using Sensia 100 film unless otherwise stated. All of the pictures, with the exception of flight shots, were taken with the lens mounted on a tripod or supported on a beanbag.

What should you buy?

The question I am asked more than any other is: 'Which camera and lens should I buy to start bird photography?' It is also the question I dread being asked more than any other, because the answer depends on many different factors. I can only advise on what has worked best for me over the years. Other photographers may use different lenses and film and be equally happy with their results as I am with mine. This doesn't mean that any one of us is more 'right'; like most things in life, it comes down to personal preference. And for the majority of us, it also depends on how much you can afford to pay.

Bird photographers may use differing lenses and film, but all are able to obtain good results.

24mm lens, 1/60sec at f11

Cameras and lenses

Let's go and buy all we need to take a good bird photograph. My wish list would include:

- Nikon F5 body
- 500mm F4 autofocus (AF) lens
- Teleconverter to match

The total cost runs into thousands. In an ideal world, this is what most people would like to buy – or the alternatives offered by other manufacturers – and this equipment will take superb photographs, providing you know what to do with it. But this sort of expense is out of most people's price range, so what else is available and how do we decide what we need to start?

For all aspects of bird photography, the 35mm system is ideal, offering a range of relatively compact cameras and lenses compared to alternative formats on the market. Within this system there is something to suit every photographer and it encompasses a broad price range – although these days, a good choice of fixed-length telephoto lenses is increasingly hard to find.

Any model of camera by one of the respected manufacturers will do a good job, but you don't necessarily have to buy the latest and most expensive model to take good photographs. As new models appear, many people part-exchange their current models to upgrade. The part-exchanged models are then available to buy at vastly reduced rates from

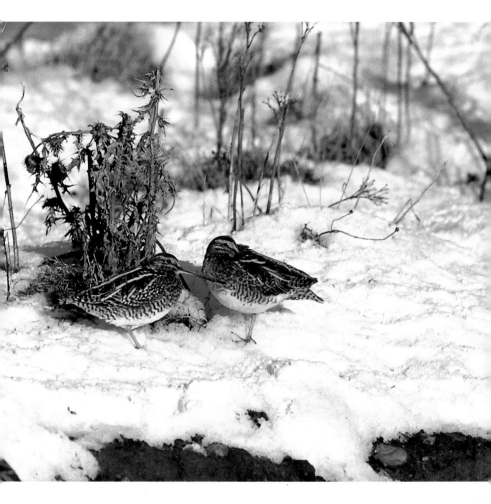

Where there is a lot of white in the image to confuse the meter, spot metering comes into its own. I took a spot reading off the bird and exposed for this at 1/250sec at f5.6, which has correctly exposed the entire scene. A reading from centre-weighted metering gave a totally incorrect exposure of 1/1000sec at f5.6, which would have produced a very dark Snipe.

Common Snipe
800mm lens, 1/250sec at f5.6

brand-new – but they are still capable of taking pictures of excellent quality. One camera I own – a Nikon F4S – was an ex-demo model and it cost two-thirds of the price of a new camera. I use it virtually every week of my photography life and it has never let me down. Buying second-hand equipment can be a very good option if your budget is a major consideration.

To help narrow down your criteria when buying a new camera, make sure that it has the following functions: auto and manual exposure mode (preferably with spot metering); ability to work with both manual and autofocus lenses (making sure that the exposure meter functions in either mode); a motor drive or autowind. Many reasonably priced models from the top manufacturers include all these options, but others don't – especially to fit manual lenses. So do pay attention and ask questions before you buy; it is worth taking the time at the start to avoid a bad purchase.

Digital cameras

In the last few years, digital photography has evolved in great strides, with the majority of the world's press photographers now using top-quality equipment.

Digital cameras do not use film. Instead, they work by recording and saving images to a memory card which can then be easily downloaded to a Mac or PC. From here, an image can be sent instantaneously anywhere in the world. For the press photographer, this type of picture is not simply ideal, but – in today's competitive news environment – absolutely essential. No more missed deadlines.

But for the bird photographer, do digital cameras represent the best option? At the time of writing, the digital photographic world is split into two types: firstly, the professional versions which are equivalent to 35mm and work with all the same lenses as that system. The number of models available on the market is, admittedly, limited, and can cost up to three times the sum of a top-of-the-range 35mm camera, but results are very impressive. The basic models are intended for the non-specialist photographer – for those who want to take general shots that don't require specific lenses. But for those who require something a little more sophisticated, cameras such as the Nikon Coolpix can be adapted to fit a telescope, and shots taken with this produce very acceptable images.

Of course, using a digital camera means that you have to also own either a computer, a printer – if you intend to view your work other than just on screen – and the software to produce the prints. There are a number of developing labs that cater for printing from memory cards, but this is not a widespread service. Digital printing is another option, especially if you are a birdwatcher who likes to take the occasional shot, rather than someone with a passionate interest in photography.

Choice of lens

Buying a lens can be even more difficult than buying a camera. Some years ago, there were quite a few independent lens manufacturers that produced good-quality reasonably priced telephoto lenses. Companies such as Tokina, Tamron and Sigma gave the would-be bird photographer a choice of 400mm or 500mm lenses to choose from but, today, the

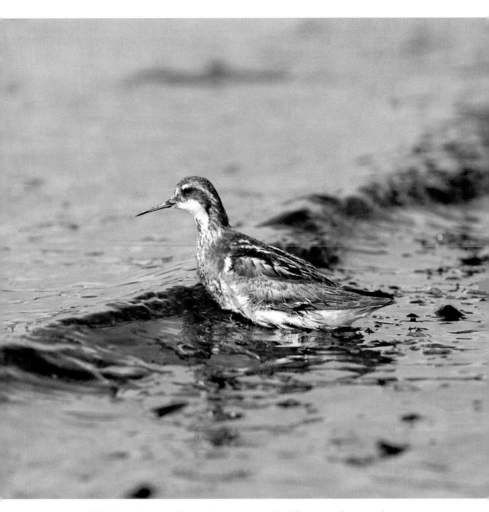

Phalaropes are often quite tame and will come close to the photographer, but they are also very fast feeders and move quickly along the water. I used autofocus to follow this individual as it swam against the waves, leaving me free to try and get the exposure and composition correct.

Red-necked Phalarope
500mm lens, 1/500sec at f5.6

emphasis has shifted away from the fixed telephoto to the zoom lens, which combines a range of focal lengths. For example, Sigma now produce a 50–500mm zoom lens, but no longer manufacture 400mm or 500mm lenses.

Really, the photographer's choice is limited to either acquiring a zoom lens from the independent manufacturers, shopping around the specialist retailers for a second-hand telephoto, or choosing one from the top camera manufacturers, which is a more expensive option. It is not an easy decision but your budget is likely to dictate the solution, so it may be best to make this the starting point. Whichever lens you choose, it needs to have at least a 400mm focal length to enable you to take a reasonable-size image without having to get too close to an easily frightened bird.

An important, but equally difficult, consideration when choosing a lens is to do with autofocus. Is it really necessary – or can the bird photographer get by with a manual lens? Without doubt, my all-time favourite lens was a manual focus 600mm f5.6 Nikkor, and judging by conversations with a number of other photographers, I am not alone in this choice. This lens has since been replaced by a 500mm AF version – a very impressive lens which produces superb-quality photographs. When I use it in AF mode, I have difficulty keeping the sensor on the bird, and in manual mode, it is not particularly easy to use either.

My reservations are really to do with the way AF lenses work. They operate with a series of sensors that aim at the subject through the viewfinder. The sharpest point of the image will be the one that the sensor identifies as the point of focus, but if the sensor moves even slightly off the intended subject, the lens

immediately refocuses on whatever the sensor targets next. For example, if you imagine a small bird flitting through a hedge: by using manual focus, you can focus on the bird and as it moves through the branches, you can track it and adjust the focus to keep it sharp, but with AF mode, every time a branch gets in front of the bird, the AF sensor alters the focus point and is in danger of misreading your subject and taking an out-of-focus bird shot. A similar example is when tracking a bird in flight. If the sensor moves off the bird, it will attempt to refocus on the nearest point – in this case, the background sky. By the time the lens refocuses to the correct distance, the bird might well have disappeared.

My 500mm lens has much further to revolve on the focusing ring than the comparable 600mm lens, and is slower to use in manual mode. These are just a couple of reasons why I find AF lenses difficult to use, but I know there are many photographers who love AF and prefer to use nothing else. My approach to AF is to be selective about using it and it works better for me that way, especially composing a picture in which the bird may not be in the centre of the frame. Some camera and lens models have AF lock buttons that enable the photographer to autofocus, lock the focus in place, recompose and then make an exposure in one sequence. I find it easier and quicker to focus manually with the bird off-centre and then just press the shutter. So, on balance, I think I would still prefer to use my damaged-beyond-repair 600mm manual lens than the AF. However, as always, it is for you to consider in depth what works best for you and your photographs, and base your decision regarding an AF lens on your own experience.

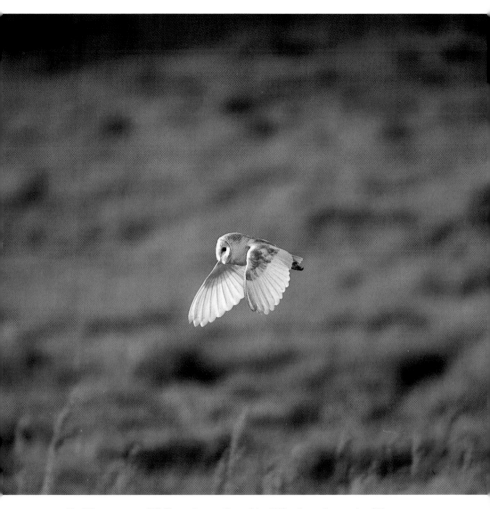

To AF or not to AF? I've always found it difficult to keep the AF sensor on a flying bird. I tried a few times on this barn owl, but ended up switching to manual focus and trusting in my own eyes and reactions.

Barn Owl
500mm lens, 1/250sec at f4

Telescopes

Telescopes can be used to take conventional photographs using a photo-adaptor. This fits onto the telescope in place of the eyepiece and is mounted to the camera, producing a lens of about 800mm length with an aperture of about f11. This telescope varies between manufacturers, but all are capable of producing acceptable results, providing a fast film and steady tripod are used.

Converters

A converter fits between the lens and camera and 'converts' the lens to a more powerful version by the magnification. For example, a 500mm lens attached to a 1.4× converter becomes a 700mm lens, or, using a 2× converter, a 1000mm lens. The main drawback is that the amount of light that can be gathered by the lens is reduced by one stop with a 1.4× and by two stops with a 2×. So, using the 1.4×, the 500mm f4 becomes a 700mm f5.6, and 1000mm f8 using a 2×. Both AF and manual models are available, but the AF lenses are slower when a converter is attached, especially with a 2×, and in some cases it is easier to switch to manual focusing.

Using a top-quality converter on a top-quality lens can produce superb results – and it can be difficult to tell if one has been used – but before buying, make sure that the converter fits the lens and camera and that the exposure meter still works. Some AF models do not work properly with manual lenses, while others do in conjunction with a specific lens. A good dealer will give you the necessary information, and it is worth taking a few test shots before you commit to buying something.

Tripods

I've said this many times before and will do so again, but a good tripod is essential in order to keep the rest of your expensive equipment steady. You can try a cheap, lightweight model, but I guarantee that you will be disappointed by the results. Camera shake will ruin virtually all of them, unless everything is completely still while the shutter is being pressed. There are many good brands and models on the market. When you buy one, though, choose one that suits your height; you don't want to stoop or kneel for every shot.

Using a tripod is basically straightforward, but it is important not to loosen the control arms too much as this causes the tripod head to wobble, which defeats the object of using it in the first place. The pan-and-tilt arms or ball-and-socket screws should be loose enough for the head to move when tracking a bird, but not so much that the head swings too freely.

Hides

Since bird photography began, the hide has been an integral piece of equipment. In the early days, it was the only way to get close enough to the subject to achieve a decent-sized image; telephoto lenses were unheard of, and the cameras not sophisticated enough to stalk birds. In those days, hides were used almost entirely for nest photography, but these days they are so versatile they can be used wherever they are required.

For those with a talent for DIY, it is possible to make your own portable hide but, for those who, like me, tend to 'destroy it yourself', there are a number of commercial hides available. If your hide is likely to be a permanent construction in a garden or at a feeding station, then buying a small garden shed may be a good alternative. Instead of fitting the windows, fit a detachable or hinged wooden panel and you have a perfect photographers' hide.

Using a small canvas hide for the first time can be a strange experience, even in familiar surroundings such as your own back garden. Once inside, you are limited to looking through the front panel and the smaller peep holes at the sides. After a while, you become accustomed to this restricted view, but it can be frustrating when a bird is nearby and you can hear it calling, but cannot see exactly where it is; you just have to wait and hope it appears in the right spot.

For a number of years, I have used the widely available 'Classic' 3 × 2ft (0.9 x 0.6m) canvas hides, but just recently I have tried out one of the new dome-shaped models. The dome is easy to use and light to carry and well worth a look if you consider buying a hide.

But where is it best to use your hide once you have one? One of the most popular places to situate a hide is at high-tide wader roosts; this is where the birds retreat when the tide overwhelms their feeding area. If this appeals to you, make sure you arrive at least a couple of hours before high tide, and that you have done your homework on how far up the beach or estuary the water will rise. Worse than looking a bit of a fool if you are washed away, you could put yourself in danger. A few days spent watching the site will guide you as to where the hide can be pitched safely.

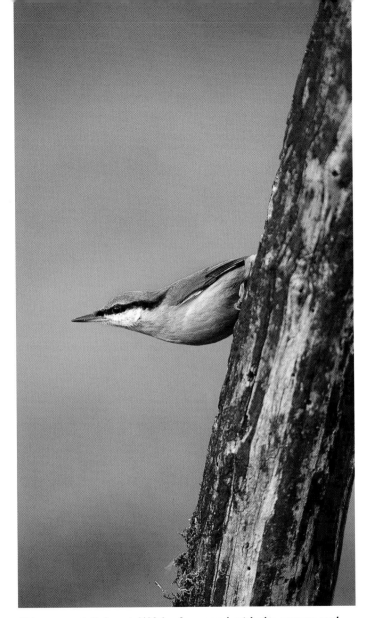

Taken on a dull day at 1/60th of a second, with the camera and lens mounted on a heavy tripod, providing excellent support. At this relatively slow shutter speed, any movement of the lens would result in camera shake and cause blur in the resultant image.

Nuthatch
500mm lens, 1/60sec at f4

Wherever you place your hide, make sure that inside it you have everything you need for your stay, including plenty of film, a tripod, spare batteries, some food and drink, and a chair to sit on. The chair may seem obvious, but I was once given the use of a hide to photograph a Purple Heron and assumed one would be provided. I was sadly mistaken and kneeling on the floor for three hours was not very comfortable.

Other bits and pieces that may come in useful include a small torch, some tape, and a pair of scissors. At bird table areas, a bradawl, screwdriver or drill for making holes in a feeding log is essential, and a pencil with a blunt end for pushing the peanuts into the holes. Do not use a penknife to cut holes in a log; they have a nasty habit of collapsing inwards when too much pressure is exerted on the blade, leading to very nasty finger cuts.

Cars can make very useful hides; birds mostly ignore them whereas they would fly away if approached on foot. Some photographers go to great lengths to cover the open window with camouflage material and fit a small tripod clamp to the sill to mount the lens on. I confess, I have never done this and I'm not sure it is necessary. I have always kept things as simple as possible, using a beanbag to rest the lens on and no camouflage. I always approach birds slowly in the car, turning the engine off and coasting the last few yards, winding down the window in advance and readying the camera on my knee. Don't forget to have all the equipment in the car ready to use, as there is nothing worse than getting in position and then remembering that the rest of your film is in the trunk!

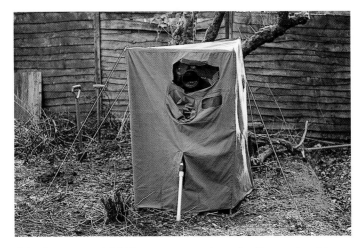

A basic commercial hide set up at a winter feeding station. I have slightly modified this one by cutting a large window at the front, as I find the camera funnel provided to be too small and low to use comfortably.

The dome hide alongside a river in Finland during the winter, erected to photograph a Dipper.

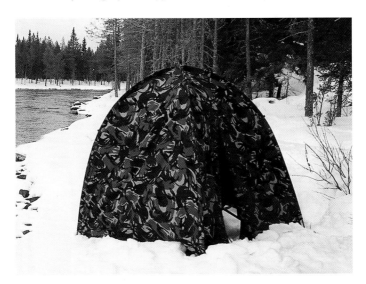

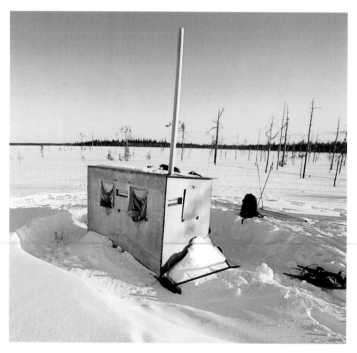

A purpose-built hide in Finland, for photographing Golden Eagles coming to carrion during the winter months. It was the height of luxury inside, with insulation and a small oil heater.

A shot taken from the hide. The eagle came very close; too close really. My 500mm lens could barely accommodate the image which literally fills the frame. Once the bird had landed, it was too late to change the lens, and the movement would have frightened it away. But the image certainly has impact!

Golden Eagle
500mm lens, 1/250sec at f8

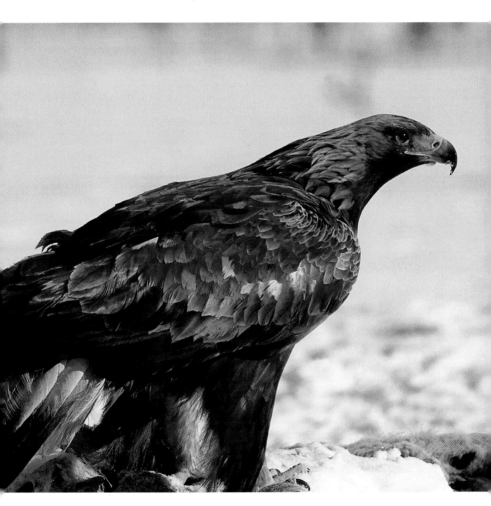

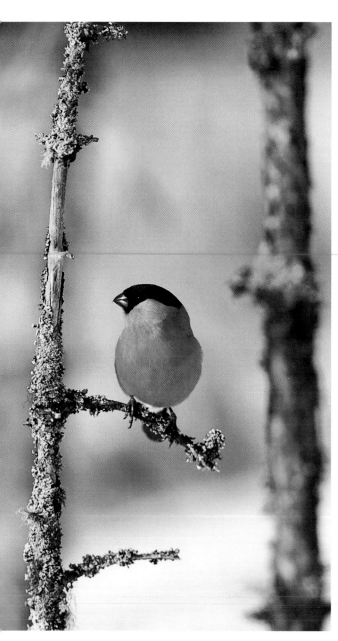

Left and facing opposite
Both these shots were taken from a dome hide situated at a feeding station in Finland. Putting the hide up in a metre of snow was an interesting experience, but the birds came down easily. Spot metering was used to avoid the large areas of snow around.

Bullfinch and Crested Tit
500mm lens, 1/250sec at f8

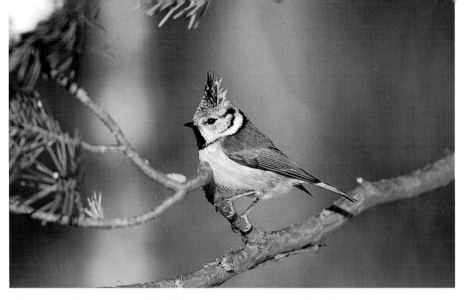

Taken from the dome hide. The Dippers showed no fear of the hide and returned to their position on the rocks as soon as I was inside. A meter reading was taken from the grey rocks and the photo exposed at this setting.

'Black-bellied' Dipper
70–300mm zoom lens at 300mm setting, 1/60sec at f4

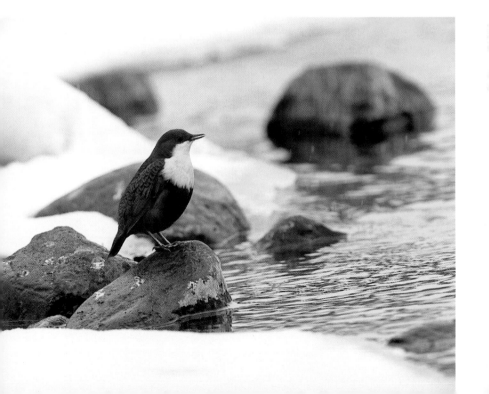

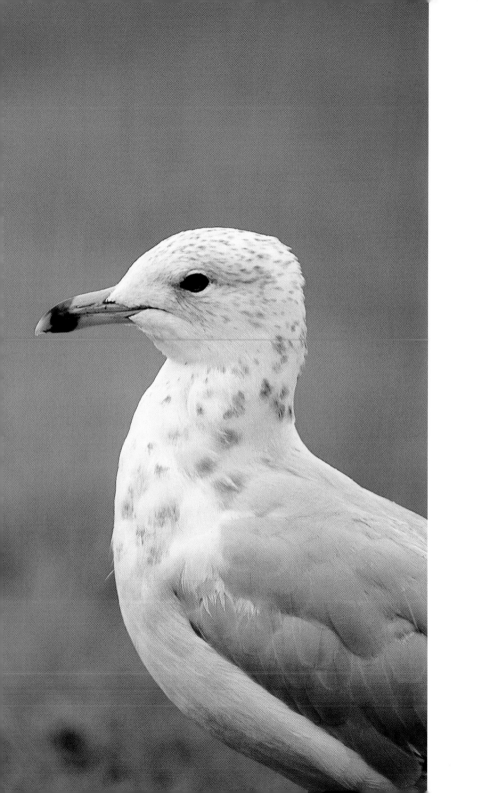

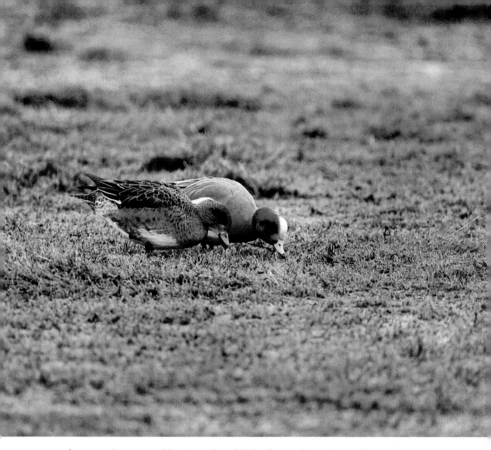

A car makes a good 'wait and see' hide. By parking alongside marshy fields, species such as Teal and these Eurasian Wigeon can be photographed.

Eurasian Wigeon
800mm lens, 1/125sec at f5.6

Cars make very good hides and can be used to take pictures of a variety of species, providing there is suitable access. This Ring-billed Gull was photographed as it came to bread thrown out of the window. At times, it was too close to focus on, but this shot was fine.

Ring-billed Gull
500mm lens, 1/125sec at f5.6

Exposure, metering and film

Exposure and metering

The correct exposure for a perfect image is achieved by allowing just the right amount of light into the camera onto the film. This is controlled by a combination of shutter speed and aperture settings, which is adjusted until it is right. Sounds simple enough, doesn't it? And with today's sophisticated cameras (and impressive advertising claims), it is difficult to believe that any photograph could be incorrectly exposed. But, allow a large patch of pale sky, snow or dark seaweed into the frame and all those autoexposure readings will start to go awry.

To test this, try a few simple experiments with your own camera. Set it on autoexposure and take a few rolls of film of any bird you see, take a note of the exposures, and then look at the results to judge which have exposed correctly. It is a good way to learn the way your camera works and, providing that you have kept a record of each shot, you should have an excellent guide for taking future exposures.

My early photographic experience involved using cameras with manual exposure control only and, by and large, once I had familiarized myself with the basics, I managed quite well. When I upgraded to a camera with an autoexposure function, I genuinely believed the hype that assured me that problems with exposure were long gone. How wrong I was, but it took me a while to realize that the camera's auto brain was at fault – and not mine! This experience has taught me that no matter what the manufacturer claims about the exposure meter, it cannot be trusted in every situation. I still use manual exposure control for probably 90 per cent of my photographs, and I

believe that if they go wrong, then I only have myself to blame – and hopefully I gain some insight for the next picture.

My approach to achieving a correct exposure for an image is to take a reading from a mid-tone area such as a grassy patch, stretch of fencing or tree bark – anything that does not reflect too much light. I then set my shutter speed to the setting given by the meter, usually leaving the aperture at f5.6, unless I'm trying to achieve a shot that calls for greater depth of field.

If, for example, I want to photograph a Mallard feeding on a grassy bank and it is a reasonably bright day, the exposure is 1/250th of a second at f5.6 on 100 ISO film, and the camera's autoexposure meter offers no complaint, as both the bird and the background are of roughly the same tone. But, if the Mallard moves from the grass onto water – which is quite bright and reflecting the white clouds – the exposure meter picks up the extra light and is fooled into believing that the entire scene is that bright. It then adjusts the exposure accordingly, setting the shutter speed to 1/500th of a second or maybe 1/1000th of a second. This means that, in the final image, the Mallard will be underexposed (i.e. very dark), whereas if the camera had been left on manual exposure at the original setting of 1/250th of a second, the Mallard would be correctly exposed.

Once again, the best way to understand auto and manual exposure is to take a series of test exposures using both, to take notes and then compare the results once the photographs are developed. It is generally advisable to use the fastest possible shutter speed when photographing birds and leave the aperture of the lens wide open, unless you are trying to achieve a specific effect. Flying or bathing birds require a

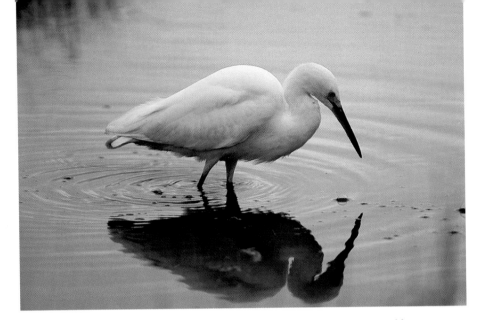

A difficult exposure to judge. The first image, above, is severely underexposed because a spot-meter reading was taken directly off the white bird. The meter has been fooled and the bird is very dark. Compare this to the one below where a reading was taken from the grass behind the bird and then a third stop less given, to allow for the white plumage and to try and achieve some detail, which has resulted in a nicely exposed shot.

Snowy Egret
800mm lens, 1/1000sec at f5.6 (above) and 1/125sec at f5.6 (below)

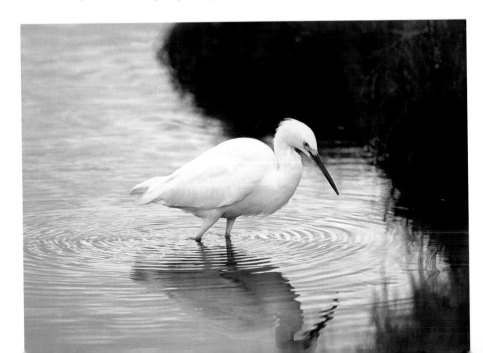

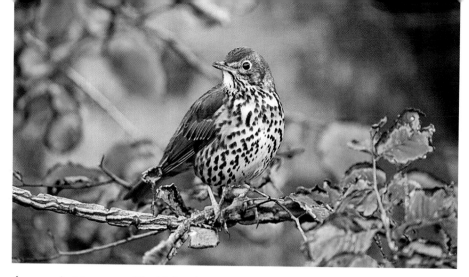

An easy shot to expose. The bird and its surroundings share the same general colouring, which won't confuse the centre-weighted metering.

Song Thrush
500mm lens, autoexposure

Below The white, snowy background confused the meter here and, if left on auto, would not allow in enough light and underexpose the image. I took a spot reading off the bird's head and exposed at that setting. If your camera does not have spot metering, then either allow at least one extra stop – 1/60sec instead of 1/125sec, for example – or take a reading from a mid-tone area where there is no snow and expose for that.

Song Thrush
500mm lens, 1/60sec at f4

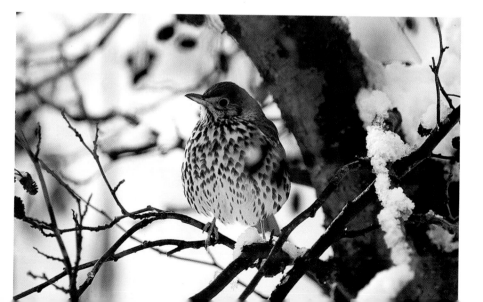

shutter speed of around 1/500–1/1000th of a second to freeze the movement, but to enhance the blurred effect of the wing movement, you might set it at 1/60th of a second. Try this out for yourself to see what happens – and be prepared to waste lots of film.

Closing or 'stopping' the aperture down will bring more of the picture in focus or, in other words, allow a wider depth of field, but will require a slower shutter speed. A shutter speed of 1/500th of a second at f4 allows the same amount of light to reach the film as 1/125th at f8. There is a two-stop difference on both exposure controls: the shutter and aperture. The depth of field that is in focus – from its sharpest to its least sharp point – will be greater on the shot exposed at f8. The higher the f-stop number, the greater the depth of field and the slower the shutter speed.

Slide versus print film

Which type of film to use can usually be resolved by thinking about the end use of the images. If they are just for your own pleasure – for displaying in notebooks or albums of species – then it is better to use print film. If, however, you plan to build up a serious library of photographs with a view to publication or to use in talks on the subject, then slide film is preferable.

If you have access to a PC or Mac, a good-quality scanner with a transparency hood and a printer, you can produce your own prints, whether you use slide or negatives, which offers you the freedom to use either or both.

Most photo agencies only accept slides. CDs containing high-resolution scans are becoming more popular, but are not universally accepted. Magazines will accept prints for publication, but only if the image is going to be reproduced at a very small size.

Every roll of film has a speed number on the box and the cassette which denotes the relative fineness of the film's grain structure. The lower the number, the finer the grain, and the sharper the image will be, while the higher the number, the coarser and more visible the grain, especially on slide film, which is less forgiving. Print film is easier because it has a greater degree of latitude. Most professional bird photographers use no higher than 100 ISO slide film, but may also use faster print films; 400 or even 800 print films can produce impressive results. Many brands of both slide and print film are available and it is worth trying different brands to see which you prefer. I tend to use Fujichrome slide and Fujicolor print films, simply because I like the colours they produce and the consistent results.

I confess, I recently exposed a full roll of 800 print film at the 400 ISO setting. I should know better, but these things happen. However, when my lab developed the roll, every print came out perfectly, and was accompanied by the comment that 'these were quite good for you'! Negatives that are overexposed by up to two stops and underexposed by about one stop will still produce a reasonable print, providing the lab compensates at the printing stage, but there is no such luxury with slide film. Transparency film has maybe only a third of a stop latitude, and will show any mistake in the exposure. Correctly exposed negatives are preferable, but correctly exposed slides are *essential*.

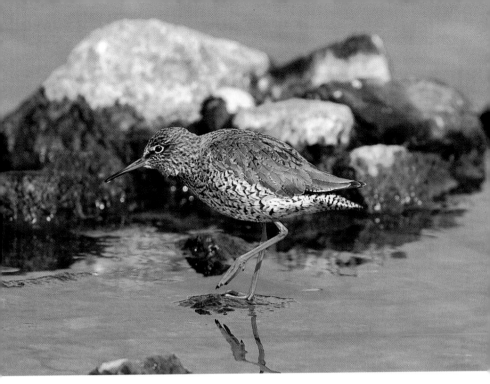

Different photographers prefer different films, but a good-quality slide film produces good colour saturation and fine grain.

Redshank
800mm lens, 1/250sec at f5.6

If you have read photographic books or magazines, you may have come across the term 'uprating' or 'pushing' a film (usually only slide film). It sounds complicated, but it actually just means exposing a film at the wrong ISO setting, and usually happens when a faster speed film is required, but unavailable. By way of an example, imagine that you are taking pictures on a sunny day, using 100 ISO film. The weather clouds over and a lot of the available light is lost. Your shutter speed drops dramatically, but you want to continue because this is your only day off for

the next two weeks. Simply by exposing the 100 film at 200 you have increased your shutter speed by one full stop, for example: from 1/60th to 1/125th of a second. In effect, you are underexposing the film by one stop. To compensate, the film must be corrected at processing (some labs make an extra charge for this service). Make sure you mark the film canister in some way; scratch it with a key if you don't have a pen with you.

Weather and light conditions

One of the biggest factors to affect successful photography is the weather, and it is the one thing that you really can't do anything about. There is nothing worse than being at work all week, with the sun shining outside – and then it pours with rain all weekend!

Good conditions are preferable for photography, but even if the weather is grim – whether flat lighting, rain, wind and snow – it is always worth carrying on. As long as the equipment is dry and I'm comfortable, I don't mind taking shots on dull days, or even in the rain. Some species, such as gulls, will show better the true tone of the shades of grey in their plumage in dull weather than bright sunshine, and photographs of birds on water, rain pattering all round them, can be quite atmospheric.

If the light is very poor, use a faster film than normal or uprate it to achieve an acceptable shutter speed. I've taken a few shots using a speed as slow as 1/30th of a second – but I have also thrown lots in the bin, too. At this speed, you increase the likelihood of camera shake, but it is always worth attempting a shot – the results may well surprise you. Failure rate is likely to be high, but makes a successful picture more satisfying.

I was photographing Redwings on what had been a nice sunny day, but the clouds rolled in and the light disappeared fast. Loathe to leave while this bird was showing so well, I decided to uprate my slide film and take a few more shots. The results can be very impressive.

Redwing
500mm lens, Sensia 100 uprated to 200, 1/125sec at f4

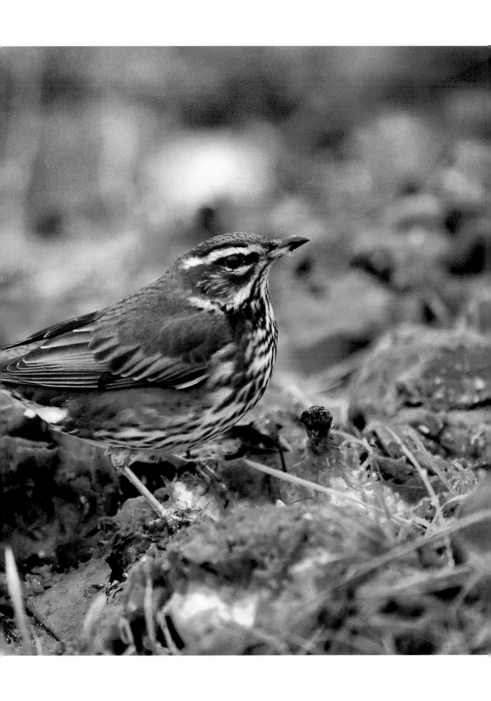

Taking photographs in sunlight can produce very different results, depending on the time of day and year. For example, by mid-afternoon in December, the light fades quite quickly. Even by 2.30pm, the light has a yellowish tinge which affects your photographs. Unless I am specifically looking for an early morning or evening effect in a photograph, I find it is only possible to work from about 10am to 2.30pm at this time of year.

If you have the opportunity to photograph birds in the snow then take advantage of it – and use lots of film. I rely on spot metering in these conditions, taking a reading from the bird or a mid-tone area such as a tree trunk or fence post. Snow gives a false reading on most centre-weighted meters because the white area confuses the meter, which can lead to an underexposed image.

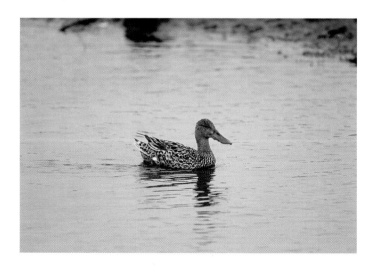

The light was too poor to freeze this juvenile Shoveler as it ran across an open area, so I panned with the bird as it walked and shot at a 1/30th of a second to show the movement. Out of six rapidly fired shots, this was the only successful one; the rest were blurred.

Shoveler
800mm lens, 1/30sec at f8

Left *This was taken on another of those days when the light changes from good to bad, but with only a few frames left, I took a few shots anyway. Taken at 1/60th of a second, I took a reading away from the water and exposed at that setting. The result is not stunning by any means, but at least I managed something at a slow speed.*

Shoveler
800mm lens, 1/60sec at f5.6

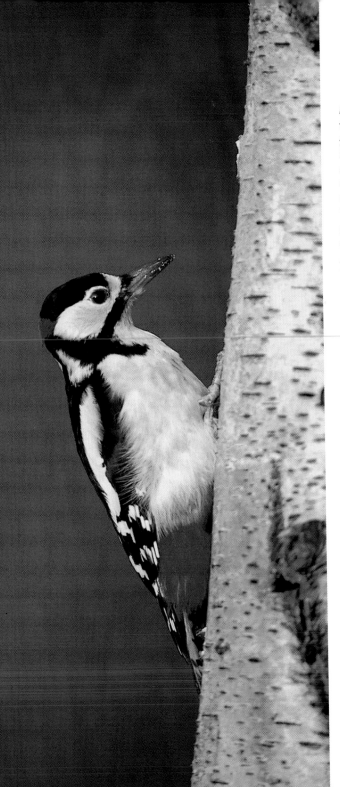

During the winter, the light is such that photographs taken late in the afternoon can show a yellow cast. Compare these two shots of Great Spotted Woodpecker, both photographed on the same day in early January; the first was taken early in the afternoon, while the second was taken at about 3pm.

Great Spotted Woodpecker
500mm lens, 1/125sec (left), 1/250sec (facing opposite) at f4

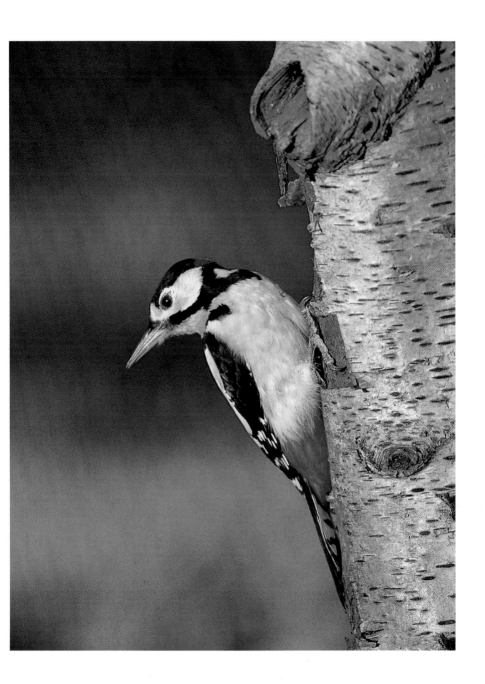

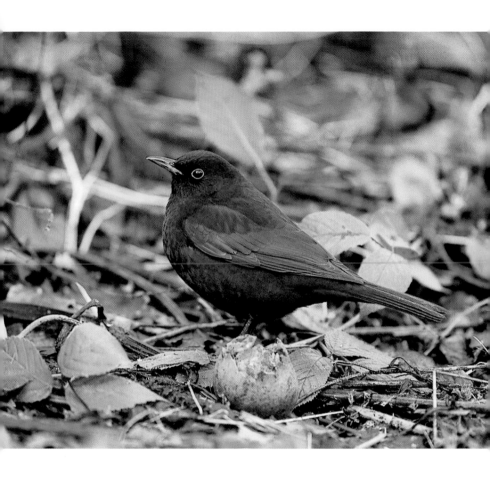

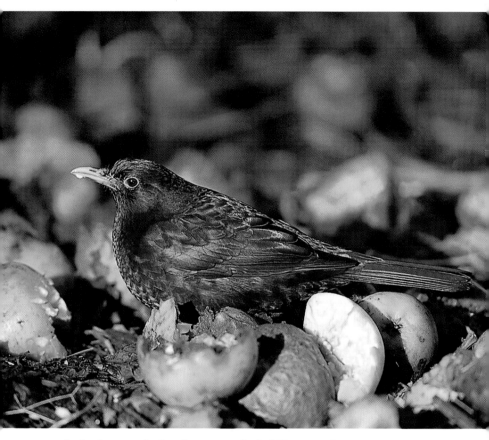

Birds photographed in the sun can look different to those photographed on a dull day. Compare these two shots of a Blackbird and see how cold the first looks, on the left, compared to the second, above, taken in full sunshine.

Blackbird
500mm lens, 1/250sec at f5.6 and 1/30sec at f4, respectively

Using flash

Using a flash outdoors can be a good way to overcome poor lighting conditions, but there are a few things to keep in mind if you do.

Setting the camera and flash on auto may seem a good idea, but many birds are just too far away for the flash to be effective. If they are nearby, but the background is a good distance behind, it will appear almost black in the photograph, which is far from ideal. Added to this is the problem of controlling 'red eye' or 'white eye' when the flash hits the eye of the bird: a frequent result of using flash.

When taking a photograph in available light, I generally have a good idea how the finished result will look, providing the bird keeps still and is in focus. Working with flash, however, is less predictable. I am never entirely sure where the flash will hit the bird or if there will be enough power to illuminate the whole scene.

Using fill-in flash is a better alternative, and provides a good lighting effect. To do this, meter the scene as normal for the camera setting and then set the flash at a reduced setting with enough power to reach the bird, but expose the background as normal. For example, on a dull winter's day,

When the going gets tough, don't go home! This Cormorant and I both sat out a blizzard; he was perched on a post, while I stayed put in my hide. It's always worth taking a few photographs, no matter what the conditions are like.

Cormorant
800mm lens, 1/30sec at f 5.6

the meter may give a reading of 1/60th of a second, which is quite slow, and there may be no sunshine to provide a highlight in the bird's eye. Fit the flash to the camera and set it to fire at −2 on the control panel instead of full power. The flash will illuminate the bird, while the natural light is metered onto the film to expose the background.

Every flash is different and you might need to experiment a little to see which settings work best for your system. In certain situations, it may be possible to set up a number of flashguns to fire simultaneously to provide even lighting across a broad range. This requires quite a bit of practice and lots of test exposures to get right. You also need to ensure that all leads, connections and flash units are compatible.

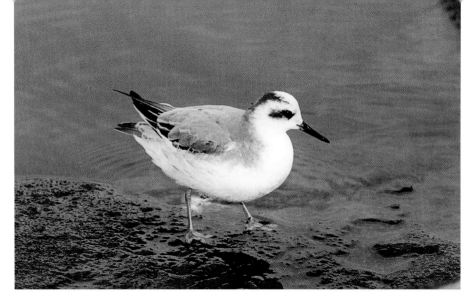

A dull day offered a perfect opportunity to use fill-in flash. The bird was looking rather flat and grey and I wanted to add some sparkle, so I set the flash to –2. The shutter on the camera was set at 1/125th of a second to expose the entire scene correctly, while the flash had enough power to reach the bird, producing a highlight in the eye and making it stand out from the background.

Grey Phalarope
70–300mm zoom lens at 200mm setting, Fujicolor 800, SB24 flash

Left and right **Both of these photos were taken using fill-in flash in exactly the same way, but have produced different results. The shutter speed was set to 1/60th on manual setting, which was the correct overall exposure, while the flash was set to –2 on the panel. The Robin (left) has been exposed perfectly, with the flash lighting the bird while the available light has lit the background. The White-collared Kingfisher (right) has been lit well enough, although the way the flash has hit the eye is not as nice as I'd have liked.**

Robin and White-collared Kingfisher
500mm lens, SB24 flash

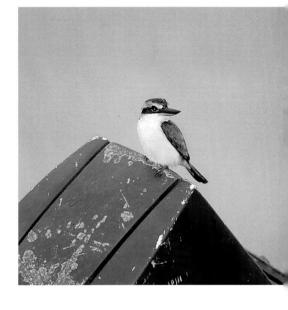

Out in the
field

Reality check

When I first began bird photography, reading about being 'out in the field' conjured up visions of days spent in the wilderness, completely alone and undisturbed, with the bird of my choice.

Being 'out in the field' is a slightly less wild reality. RSPB (Royal Society for the Protection of Birds) and WWT (Wildfowl and Wetlands Trust) reserves and my local parks attract lots of birds to photograph, but are also full of visitors, many of whom like to interrupt the photography by asking questions such as 'How far does your lens go?'. These places are a compromise; for many people, with only one day a week to spare, they provide the only opportunity for being 'out in the field'.

It is possible to go somewhere more remote, but it is more involved. Setting up a hide in the wilds of the Welsh mountains to photograph Buzzards feeding on a dead rabbit is a great idea. But actually doing it is difficult for a five-day-a-week working person. You need to find someone who can take you to the site; get the necessary permission to photograph on private land; bait the site regularly to attract birds; and, finally, have enough time to sit and wait for the birds to appear.

But just being out and about with your camera equipment can be a fruitful exercise. It means that you can familiarize yourself with the controls; learn about focusing and exposure, and deal with problems that occur all the time – whether photographing in the wilds of the mountains or in the local park.

So, for a day out in the field, what do you need to take with you? My advice is take everything that you possibly can, because you can be assured that the one piece of equipment left behind will be

This camera bag will hold most photographers' equipment, including a lens up to 500mm.

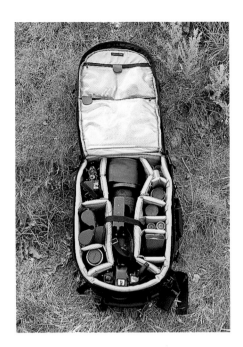

the one piece that you need. I carry all my photographic gear in a Lowepro Photo Trekker AW bag (but a same-sized alternative will do). This easily accommodates a 500mm lens attached to a camera body, a 70–300mm zoom lens, 24mm and 50mm lenses, a flashgun, a second camera body, a pair of binoculars and various other bits and pieces such as spare batteries, one or two filters – oh, and plenty of film. The only item that doesn't fit is my 800mm lens, which I carry in the boot (or trunk) of the car in its own aluminium case. I also keep my tripod in the car – never forget it, as there is nothing worse than arriving on site and realizing it is still at home.

The species I am trying to photograph determines which lens and film I use; other influences, such as weather and lighting, also have an impact. For example, if I'm at a feeding station, I will set

up a hide specifically for my 500mm lens and leave any others behind. If I were trying to capture a rarity, I would make sure that I had my longest lens and some converters in my pocket. But no matter what I photograph, I nearly always play safe and have most of my equipment in the trunk of the car, just in case.

One extra item that I wish I could pack in the bag is patience! Birds test your patience to the absolute limit. Be prepared for disappointment and frustration – not only while waiting for a bird, but for it to show and perform well when it does finally appear.

Field checklists

These checklists are intended as a guide to help ensure that the important items aren't left behind when you need them most.

General checklist

If you are heading for a general day out taking pictures, I recommend throwing everything you have in the trunk of the car. It doesn't take much longer to load an extra bag containing a spare camera body, or more film than you think you'll need. It is always better to have too much of everything, than not enough.

Film

The most obvious thing to check I know, but there is nothing worse than pressing the shutter and then realizing you have no film. Remember; it may be a week since you last used the camera and you may have already taken out the previous film even though it wasn't finished, just to see what you have.

Batteries

There are so many different types now available that it is impossible to give a guideline as to how long a set may last. The camera's instruction book generally provides a chart, but it is difficult to keep track of how many rolls you have used, so always carry a spare set.

Tripod

It's no good having the best camera and lens in the world, if you cannot keep it steady. Take with you a spare quick-release plate or tripod screw, too. Many birders leave the mount on their telescope, and then have no way of mounting the lens on the tripod.

Beanbag

If shooting from a car window, this is essential and I tend to have a few, leaving one permanently in the car, one at my local reserve hide and the other in the boot.

Waterproof cover

This can be be very useful if the weather is showery, to save packing everything away. Commercial models are available to fit most camera bodies and lenses up to 500mm.

Additional items

- Notebook for keeping record of exposures – or keep a copy of this handy guide and use the notebook section at the back
- Pen/pencil

Feeding station hide checklist

- Camera, lens, film, tripod and spare batteries
- Chair

- Food and drink
- Torch
- Spade. This is necessary for digging holes for log perches and can itself be used as the classic Robin perch
- Small drill, bradawl or screwdriver for making holes in logs
- Pencil or something blunt-ended for pushing and crushing peanuts into holes
- *A Field Guide to Bird Photography*
- Pen/pencil

Estuary hide checklist

- Camera, lens, film, tripod and spare batteries
- Chair
- Food and drink
- Torch
- Binoculars. It's nice to watch birds when out walking
- Wellington boots. It could be a wet walk, and wet in the hide, too, if you get the tide wrong
- Chisel and hammer. These can be useful if the hide is on hard ground and you need to erect poles
- *A Field Guide to Bird Photography*
- Pen/pencil

Car hide checklist

- All equipment inside the car
- Beanbag or window clamp
- Binoculars
- *A Field Guide to Bird Photography*
- Pen/pencil

Overseas trip checklist

- Passport and airline tickets. It doesn't matter how many cameras you remember, you won't go anywhere without these
- All the equipment you can possibly manage. If you can, take it on board as hand luggage but some airlines are very strict about this and may not allow it
- Work out how much film you will need – and double it. Take the film in your hand luggage as bags and cases stowed in the hold are subject to more powerful x-rays
- Batteries, plus a spare set
- Identification book: always useful in a new country
- Binoculars
- *A Field Guide to Bird Photography*
- Pen/pencil

You should have no excuses for leaving anything behind ever again – unless you forget to read this checklist section, of course.

Bird photography, for most people, is a hobby to enjoy more than anything else, but if you really get hooked, it can become an all-consuming passion. The more photographs you take, the better you will become, until the process becomes more automatic. Your photographs might only rarely be perfect, but those few brief seconds when you press the shutter and think you have a great picture will more than make up for all the not-so-good ones. It is a frustrating hobby at times, but it is worth persevering with it – if just for those days when you have a bird in the viewfinder that is so close, you can see it breathing. There is a lot of luck involved, but my attitude is that the more time you spend in the field, the luckier you will become.

Three days in the field

This section deals with three actual days that I have spent
out and about taking photographs. The three sites that
feature here are very different from each other: one is a
nature reserve in the UK, near to where I live; a second is
a winter feeding station that could be almost anywhere,
while the third is on the Isles of Scilly off the coast of
Cornwall in the UK, where I gave myself the task of
photographing a single species for a day. On each of the
three days, I learnt a lot about birds and photography.
All the problems, solutions and results are shown – including
some of the bad ones.

Seaforth Nature Reserve, UK May

In the early 1980s, I took my first photographs of a Little
Gull using a cheap camera and some black-and-white film.
More than any other, this species got me hooked on trying
to achieve the perfect image of a specific bird and with every
subsequent year, has become an all-consuming affair.
The Little Gulls that can be seen at this nature reserve breed
in Finland, and each spring, from early April onwards,
numbers build up as the birds gather in large flocks before
migrating north to their breeding area. Why they use this
spot is something of a mystery, but there is a good food
supply and the site is near the wintering grounds of the Irish
Sea. Whatever the reason, I am extremely grateful. Each
spring, I sit in the hide for days on end just waiting for the
right moment to press the shutter.

This spring was no different, except that the birds had chosen to feed on a nearby marina, only visiting the reserve itself occasionally. By early May, I had not taken a single photo but, suddenly, the small remaining flock of about forty birds decided to move to the reserve. Would they come close enough to the hide so that I could take some good photographs?

I had been visiting regularly for the last three days and had managed a few shots but, frustratingly, the birds were that little bit too far away from the viewing hides. By looking through the viewfinder, I knew this was the case, but was unable to resist taking a few pictures (all of which were subsequently filed straight in the bin!). But that day, things looked promising: the weather was bright with hazy sunshine, there was little or no wind and there were plenty of small flies that the gulls liked to feed on.

In the hide, I had all my lenses, plenty of film and a beanbag to rest my lens on through the hide window. I prefer to use a beanbag rather than a tripod as it gives me greater mobility to move around the hide, and it allows other visitors enough room to move, too. I had two camera bodies, both loaded with Fujichrome Sensia 100 slide film: one attached to a 500mm lens, the other to an 800mm lens. I had already taken a meter reading and set the shutter speed to 1/500th of a second at an aperture of f5.6/f8; Little Gulls are fast swimmers and dart around as they catch flies, so a fast shutter speed was essential to freeze the movement. Because the subject was largely white, I didn't trust the auto metering system and used manual, taking a reading from the nearby grey rocks, and then underexposing by half a stop to try and achieve some feather detail.

After a short while, one of the adult birds began to approach the hide quite closely, actively feeding on the water. The bird's black hood meant that I needed to ensure that I captured a highlight in its eye; without it, the eye would disappear into the blackness of the hood, which makes for a surprisingly poor photograph. I switched my 500mm lens to AF mode to allow me to concentrate on tracking the gull as it swam at speed across the water; the motor drive was on continuous high and, as it moved across the hide, I gently pressed the shutter leaving my finger in place. A burst of seven or eight frames was taken – just as the bird turned its head away. It turned around and I fired another short burst, instinctively knowing that if everything was right, I had a good-looking shot in the sequence. It was just the pose I had been waiting for. In the next four hours, the Little Gulls put on a show that I have never seen before at Seaforth in all the years I've been there. They swam close to the hide, called and fed; there were first years, second years and adults in both winter and summer plumage all present. It was almost possible to build up a comprehensive file in a single day! I took fifteen rolls of film in about five hours and, of those 540 exposures, how many were good? In fact, there were plenty of good ones and there were a lot of bad ones, but there were also a few of the best shots of this species that I had ever taken. The bad shots are not important; birds are always going to turn their heads away now and then, and changes in light will affect the exposure. All photographers reject lots of shots, but will also have maybe four or five good ones per roll, plus maybe one very good one – and these are the ones that matter.

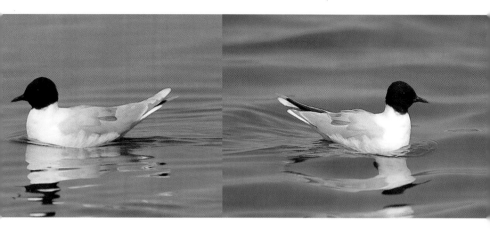

Beautiful, dainty, fast-moving, charismatic – and difficult to photograph – Little Gulls are probably my favourite subjects. This was one of the best days I can remember for photography; when everything came together and the results were worth all the effort.

Little Gulls
500mm or 800mm lens, 1/500sec at f5.6/f8

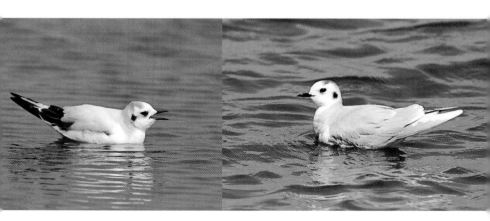

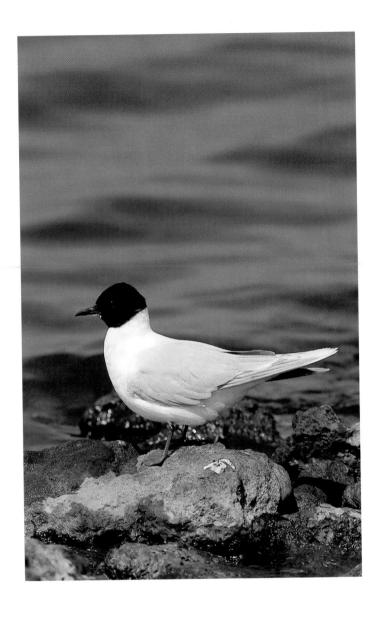

Little Gull
500mm or 800mm lens, 1/500sec at f5.6/f8

So, was all the effort worth it? Well, I believe it was. I have some nice photographs of one of my favourite birds that I know will be of good use in the future. Fifteen rolls may seem excessive, but it is difficult to stop taking photographs when the birds are performing so well, and this applies to every species, not just Little Gull. And it is always better to look back and wonder why you took so many, than to wish that you had taken more.

Winter feeding station, UK March

I had started this feeding station on private land early in January and, by March, the birds were becoming used to it and visiting in reasonable numbers. Feeders had been hung on tree branches, a small canvas hide had been erected into a permanent position, and I had placed a couple of perches in strategic spots to encourage the birds to land on them. I had also found a couple of nice logs in which I had made holes to stuff with peanuts and fat. These were intended to attract Great Spotted Woodpeckers and Nuthatches, which I hoped would find the tasty menu irresistible and cling to the side of the log while I took roll after roll of film.

But the harsh realities of life – and bird photography in particular – were brought home to me once again as I sat in the hide for a session and saw little more than a couple of Blue Tits, Great Tits and a Robin, which I watched and photographed anyway. After a few more sessions, other species became accustomed to this new supply of food and began to visit. At first, the Great Spotted Woodpecker landed on the log, but would fly off again almost immediately, giving me little

chance to even get the bird in focus! Its next few visits lasted
a little longer, but usually came to an end in an explosion
of wings when I pressed the shutter, and produced some very
blurred images on my slide film. But, one day, everything
I could hope for came together.

By mid-March, the birds had acclimatized to the sound
of the shutter being pressed and paid no attention to it;
they were even sitting around in the bushes while I put out
food. Some Blue Tits even came down as I was walking
back to the hide. Inside, I mounted my 500mm lens on a
tripod, focused on the feeding log, loaded the camera with
100 ISO slide film, checked the exposure reading from a
mid-toned grassy area, and looked through the window –
just as two Jays appeared on the log in front of me. I was
amazed! This was the first time I'd seen a Jay on the food
and there were two at once, almost too close to focus on.
I took a few quick shots and then saw that the male Great
Spotted Woodpecker was perched on the side of the log in
beautiful sunshine. I refocused and took a quick sequence
of six or seven shots as he moved up and down the log,
before he moved to a second perch that I had positioned
only that morning. I took some more shots before
transferring my attention to a Long-tailed Tit that was
sitting in exactly the place I hoped it would, on a twig
I had inserted in the ground. Blackbird, Blue Tit and Great
Tit, Robin and Chaffinch were also all photographed on this
one day. After three hours and ten rolls of film, most of the
excitement was over and I left the hide, happy that I had
some good shots in the bag.

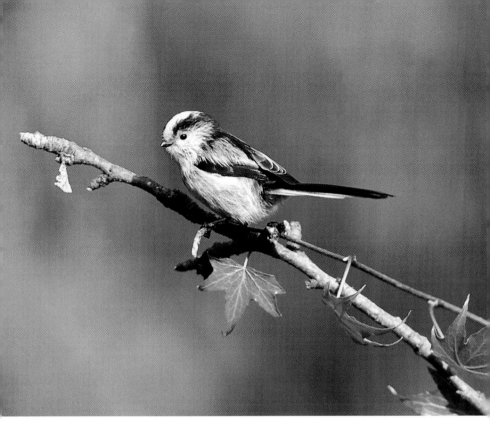

Every perch – in this photograph and the two that follow on pages 66 and 67 – has been erected specifically for the birds to land on – and this time it worked! There is a bag of peanuts just out of shot of the Long-tailed Tit.

Long-tailed Tit
500mm lens, 1/250sec at f5.6

Feeding stations are great places to practise your photography and learn what works and what doesn't. Because I know roughly where most of the birds are going to be, I tend to avoid using the AF mode in this situation and prefer manual instead, which also saves battery power. Autoexposure is generally fine, but beware of birds moving up against the sky, which may confuse the meter. Try different settings, keep records and see what works best.

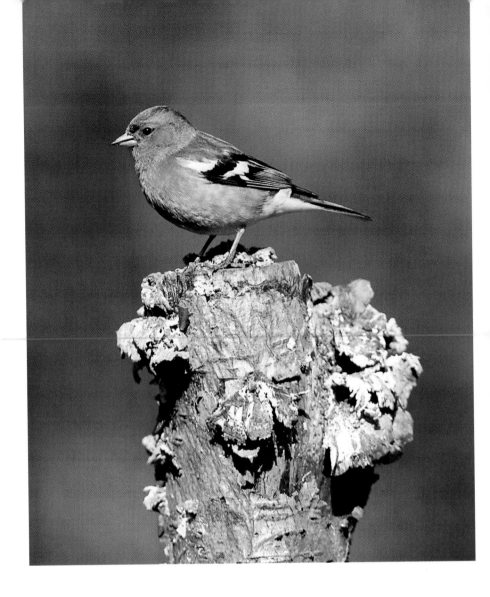

The perch on which the Chaffinch is sitting has seed hidden in a hole by its feet. The log on which the woodpecker is clinging has holes filled with crushed peanuts.

Chaffinch and Great Spotted Woodpecker
500mm lens, 1/250sec at f5.6

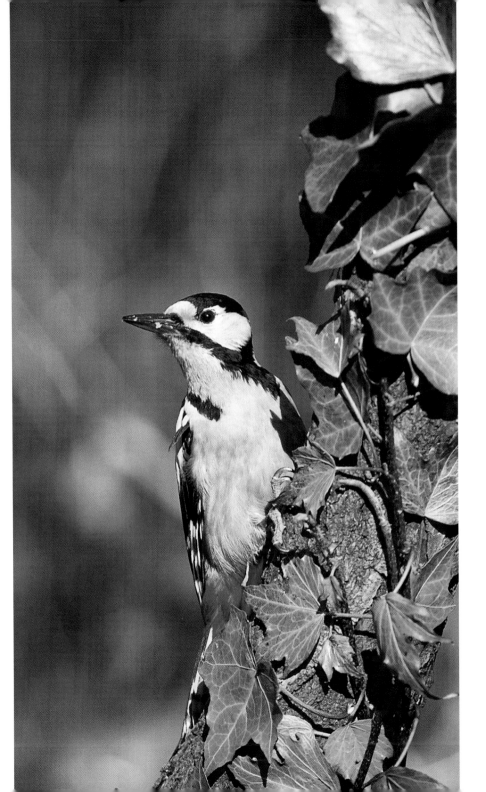

Isles of Scilly

The Isles of Scilly are home to some of the rarest birds to visit Britain during autumn migration time, and are visited by hundreds of birdwatchers, all eager to see the latest bird to arrive on these beautiful islands. There are also a handful of photographers, keen to capture a picture of these rarities.

For this type of bird photography, forget about putting up a hide; there are far too many other people around to make that a possibility. Instead, you will need a long lens, converters, a fast film and lots of patience. Basically, you have to wait and hope that the bird comes close enough to be photographed or, in some cases, attempt to stalk the bird without flushing it away.

I've photographed many rarities in different places over the years, but Scilly is my favourite destination in the British Isles. This particular day began dull and wet – the sort of day photographers prefer to spend inside drinking coffee than outside in the rain, trying to take pictures. But as usual, fate decided to have some good birds turn up in lousy weather.

A Pied Wheatear was seen on Porthcressa Beach which led to 300 people standing in a very large semicircle on the wet sand and seaweed, watching this first record for Scilly. As the rain drizzled, I tried to take a few record shots just in case it was never seen again, but when the exposure meter gave a reading of 1/30th of a second, I gave up.

Luckily, the weather brightened during the morning, the bird stayed where it was and, once the crowds had been afforded good views, they dispersed. The Wheatear put on a great show for the assembled photographers, feeding among the rocks and seaweed, and there was no problem obtaining good images.

Using an 800mm lens mounted on my Gitzo tripod, I took a nice series of shots of the bird looking even better as the sun broke through the clouds.

Inspired and in good spirits by this encounter, I headed for the opposite end of the island where a Wryneck had reportedly been showing very well. It must be explained that a birdwatcher's opinion of a bird showing well usually differs greatly from that of a photographer. But, on this occasion, as I struggled to focus my 800mm lens close enough, I had to admit that this bird had definitely been described accurately. Feeding on a stone wall, it was oblivious to the small, watching crowd and was another easy subject to photograph. The conditions for exposure were good, too, as the general brown and grey colouring of the bird posed no problems for the camera's metering system. The main problem was moving far enough away to focus on it! On Scilly, to remain mobile, I tend not to carry a heavy bag around with me, but just take what I think I will need, so, unfortunately, my 70–300mm lens, which would have been ideal for this shot, was at home.

The route back was a long, but pleasant walk and took me through the only golf course on the islands. A Dotterel had been present for a couple of days and was still on the fifth fairway, running up and down and feeding on insects as it went. Dotterel are usually tame and relatively easy to photograph, and this juvenile bird was no exception. A slow approach, keeping alongside it, and metering directly off the bird using a centre-weighted setting, produced perfect results. The third good bird of the day caught on film – a perfect day in a perfect setting. If only they were all as good as this.

Tame beyond belief, this Wryneck made a mockery of my 800mm lens; I had to back away to take photographs. A little bit of sun would have been perfect, but I am pleased with the result.

Wryneck
800mm lens, 1/125sec at f5.6

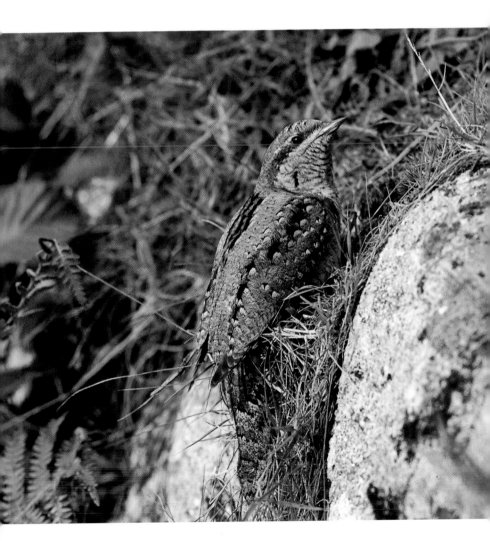

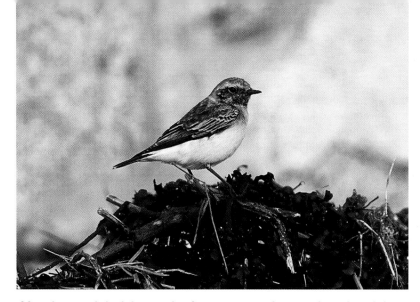

After the crowds had dispersed, a few remaining photographers shared the beach with this Pied Wheatear, which posed on rocks, twigs and seaweed.

Pied Wheatear
800mm lens, programme mode

Even the easy birds can give you some difficult moments.

Dotterel (just)
800mm lens, autoexposure and a slightly-too-slow photographer!

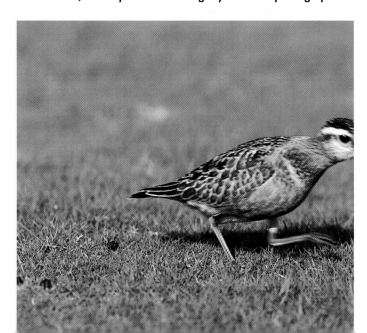

Once they start feeding, it is impossible to freeze the head of a woodpecker, but sometimes the frustration of waiting takes over and you press the shutter anyway.

Great Spotted Woodpecker
500mm lens, 1/250sec at f4

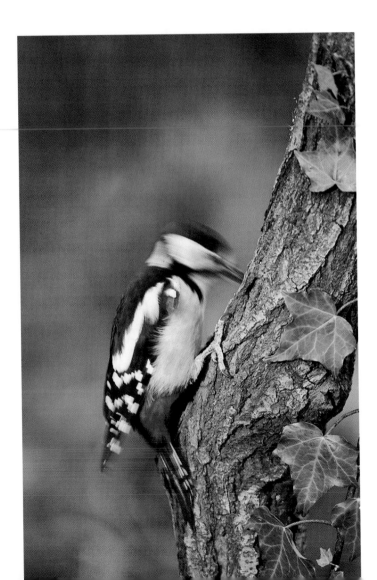

So: three days in the field photographing completely diverse species of birds in different settings, each with its own unique dilemmas. Being out and about with the camera and lens will always throw up problems, both with birds and equipment but, with experience, you will learn how to deal with them.

Not all days out are as productive as these and sometimes one will go wrong. Even on those good days, as you look at the photographs, you will find yourself wondering, 'Now, why did I press the shutter at that precise moment?'.

To round off the day, this juvenile Dotterel was very approachable on the island's golf course and an easy subject to meter. I used centre-weighted metering on auto mode.

Dotterel
800mm lens, autoexposure

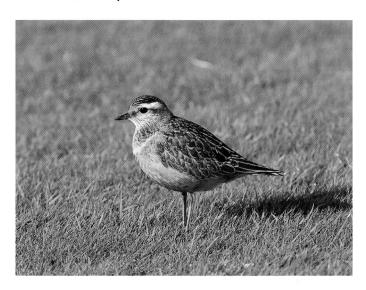

The
photographer's
year

Something for every season

One of the best things about bird photography is that it is never out of season, and your hobby can continue throughout the year. The seasons may change and the birds with them, but there is always something of interest to photograph, no matter what time of year it is. This section deals with some of the birds and trips I have undertaken over what is actually a long period of time, but which, for our purposes, forms a realistic year in the life of a bird photographer. For those whose photography is restricted to one or two days a week, the odd weekend away and an annual trip, I hope this section will be of use for planning your next project.

I like to set myself a list of targets or projects for the year so that I have something to aim for. In January of each year, I sit down and write a list of birds to photograph and places to visit that will give me a realistic chance of reaching my target. I may not make it, but at least I'll have fun trying! Other ideas to think about in advance include targeting a single species throughout the year and photographing all aspects of it: feeding, bathing, flying, mating, different plumage stages, etc. Or to aim to photograph through the coming year all the different age groups of birds that take a long time to reach maturity, such as the large gulls.

Any bird makes a good subject for a photographic project, but try to choose one that will offer you real opportunities for taking some good shots. This winter, I particularly wanted to attempt some pictures of Goldeneye in display and mating. I partially succeeded – but next winter I will be out trying again.

Goldeneye
500mm lens, 1/250sec at f5.6

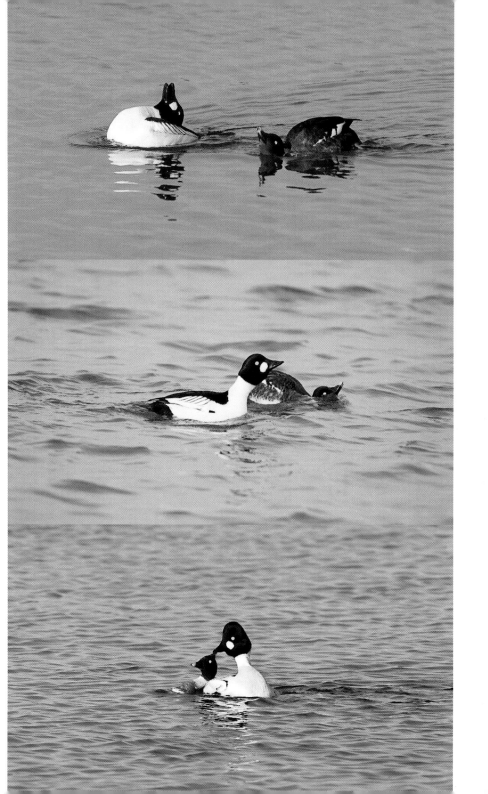

In the UK, many of the species that can be seen during different seasons overlap, so some of those mentioned here for a specific month or season might also be around during the next, so this is intended as a guide only. This rule applies to the changing seasons in other countries, too. Wherever you are, build up a portfolio of knowledge on your own patch and birding habits so that you are aware of the best times to see different species.

Winter

The winter season is probably the bird photographer's busiest time, with the days so short and many birds to photograph. The arrival of geese, ducks, swans and waders, plus lots of hungry garden birds visiting feeding stations means that there is always a good subject waiting for a camera to be pointed at it. Autumn is not yet in full swing when migrating birds leave their breeding grounds and return to their wintering areas. Most feeding stations that have not been maintained through the summer, start again in autumn so the winter season has a long lifespan.

Wildfowl

The ducks, geese and swans that arrive for the winter season have long been one of my favourite subjects. There are so many different species and variations in plumage that the list of photographic opportunities is thankfully never-ending. I like to build up a file on different species, maybe concentrating on a couple of birds throughout the winter, but ever-ready to photograph something else if it appears before my lens.
If transport is a problem for you, the lakes at local parks often

feature a good number of wild duck during the winter. Species such as Tufted Duck, Pochard, Mallard, Mute Swan, Canada Goose and, occasionally, Goldeneye can all be seen at my local park. Many will come to bread and can be confiding and easy to photograph but, when they do, don't just take a standard portrait. Try to photograph the birds bathing, flapping their wings, preening their feathers, a shot of birds in flight or the males' mating display. You might try shooting at different shutter speeds for different effects; 1/60th of a second instead of 1/500th to produce lots of blurred wing action which can look effective, while a faster shutter speed – at least 1/1000th of a second – will freeze the action. For a greater variety of species, you will need to travel away from the parks to larger lakes, reservoirs or grazing marshes where it may be possible to photograph Scaup, Red-breasted Merganser, Wigeon and Teal.

Geese are more wary than ducks and swans, but it is possible to locate them and get some good pictures. Different species favour different areas but there is often some overlap, so you may be surprised by something unusual. For example, in the UK, Barnacle Geese flocks are regular seen at Caerlaverlock in Scotland, while Pink-footed Geese can be seen in Lancashire and Norfolk, and Brent Geese are common around the Yorkshire and Norfolk coasts. But smaller groups of each species may sometimes turn up among larger flocks of other birds. Flocks of geese carpeting fields or marshes make good photographs, as do shots of thousands of birds taking off at once. Try a mid-range telephoto or zoom lens to make sure you get the whole flock including some of the habitat, or a longer lens to take some close-up shots of smaller groups.

Whooper and Bewick's Swans travel thousands of miles to
spend the winter in Britain and can be seen in large flocks at
a number of sites around the country, such as Martin Mere in
Lancashire and Welney in Norfolk. Many come close enough
to the hides to be photographed, although it can sometimes
be difficult to isolate an individual from the flock to do
portrait shots. I like to take lots of different pictures of these
birds including groups, head shots and of a variety of ages –
the young birds have a much duller grey plumage than the
adults. Remember that lots of white in a shot will confuse the
exposure meter, so take bracketed exposures to see which
works best. When photographing swans, for example, I tend
to underexpose by a half to one stop to ensure some feather
detail, but it also depends on other conditions, too, such as
how bright the sun is on the day.

*Whooper Swans migrate thousands of miles to spend their winter in Britain.
They are relatively easy subjects to photograph, but can cause problems
for the exposure meter with so much white on show. For this shot I have
underexposed by one stop, shooting at f8 instead of the f5.6 setting advised
by the meter.*

Whooper Swans
70–300mm zoom lens at 105mm setting, 1/250sec at f8

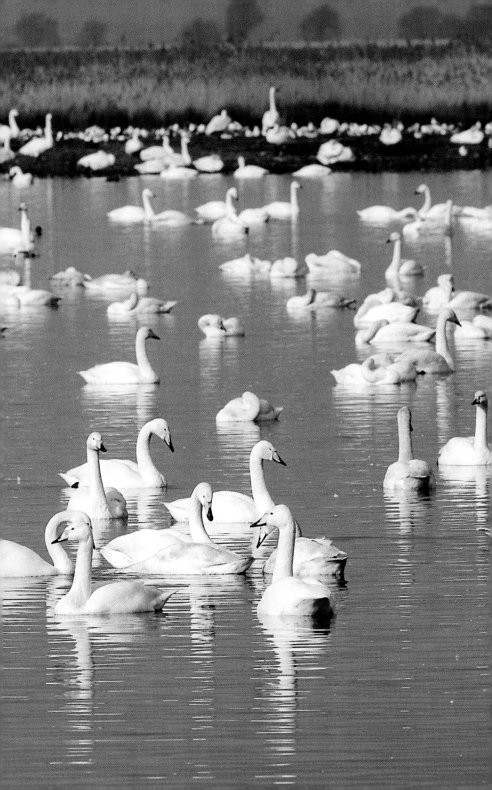

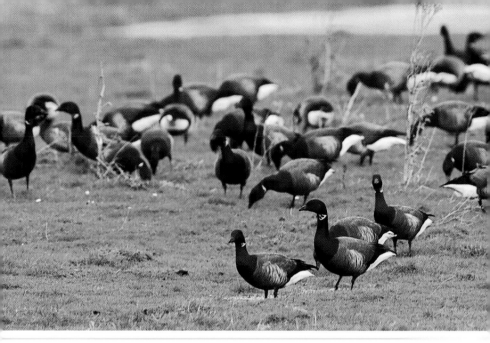

Above **A simple shot, taken from the car alongside the coastal fields of Norfolk in England where this species of geese can easily be found during the winter.**

Brent Geese
500mm lens, 1/250sec at f8

Top right **This is a basic shot, but one that can still cause problems on a windy day, with the bird moving about on the water.**

Pochard
300mm lens, 1/250sec at f5.6

Right **As well as portrait shots, other aspects of birds' behaviour can make good photographs. Feeding time at a wildfowl reserve is guaranteed to bring in flocks of swans and ducks.**

24mm lens, 1/60sec at f8, polarizing filter

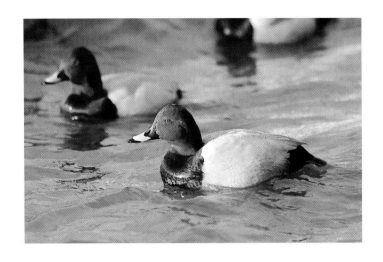

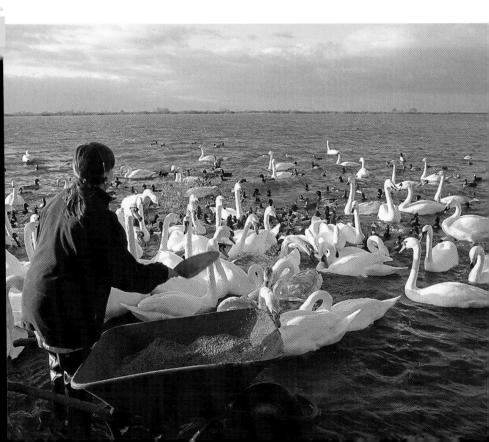

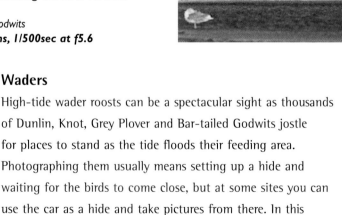

Previous page **This is a different feeding shot. I tried shooting at a slower shutter speed to show the splashing of the Pochard frantically diving for food. The Whooper Swan has decided to remain aloof from all the activity.**

300mm lens, 1/30sec at f11

Right **High tide on the coast can offer good possibilities for flight shots of wader flocks. This shot of Bar-tailed Godwits was taken from the car just as the tide was moving in, making the birds restless.**

Bar-tailed Godwits
500mm lens, 1/500sec at f5.6

Waders

High-tide wader roosts can be a spectacular sight as thousands of Dunlin, Knot, Grey Plover and Bar-tailed Godwits jostle for places to stand as the tide floods their feeding area. Photographing them usually means setting up a hide and waiting for the birds to come close, but at some sites you can use the car as a hide and take pictures from there. In this situation, individual portraits are impossible and I always

concentrate on getting lots of group shots, especially group flight shots; the birds are often quite jittery at this time and take repeated short flights before settling down again.

During actual high tide, when the flock cannot feed, the birds become inactive and roost, but as the tide recedes many birds preen and bathe in the puddles, offering good opportunities for a range of different pictures.

Feeding stations

Working at a feeding station throughout the winter is one of my favourite types of bird photography. Seeing which birds come down and encouraging them to perch where you want them to is a time-consuming, but highly enjoyable exercise.

I was recently given the opportunity to start a new feeding area, and it was fascinating to see how quickly the birds became accustomed to it, and the way more and more birds came down as the word spread among them. The first thing I did was to choose a spot to erect my hide, and then to position various feeders, scatter seed on a log table and across the ground and lay out lots of apples. I then erected a feeding log which is an old rotten log with holes down one side, filled with crushed nuts or fat. It can sometimes take a while for the birds to find it, but you can always rely on Blue Tits to lead the way! Thrushes, such as Blackbird, Redwing and Fieldfare, are attracted to the apples and look good pictured among them. A few perches placed near feeders or the bird table enable birds to land on them before feeding, which also results in a nice-looking shot.

There are different types of feeding stations to cater for other species, too, such as Red Kite in Wales, and a number of vulture species in Greece to name but a few. The mixed nuts are replaced with chopped, raw meat for the kites, and whole carcasses for the vultures.

In terms of views, too, the sites differ greatly; some are very accessible while at others, the views are more distant. For flight shots at feeding stations, I like to use a 300mm or 500mm lens and shoot at the fastest speed possible, which I recommend you begin with – unless you intend trying for a blurred effect.

The feeding log is essential to every feeding station. Holes are made, filled with fat or crushed nuts, then the log is mounted firmly into the ground with the feeding side out of view of the lens. As a finishing natural touch, a few strands of ivy can be added, held in place by Blu-Tack (although, beware, when it gets wet or it is frosty, this can become unstuck). The Great Spotted Woodpecker on page 67 was taken as it fed on this log.

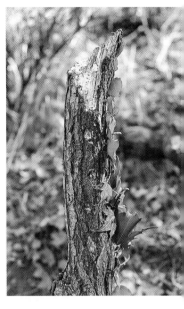

Apples scattered on the ground attracts thrushes such as Fieldfare, producing a nice straightforward shot.

Fieldfare
500mm lens, 1/125sec at f5.6

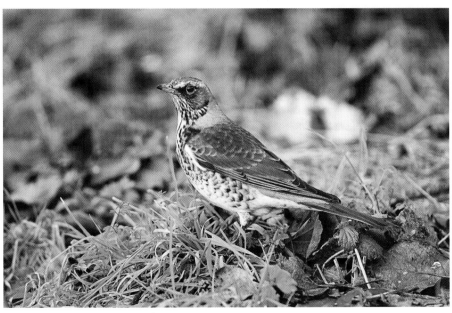

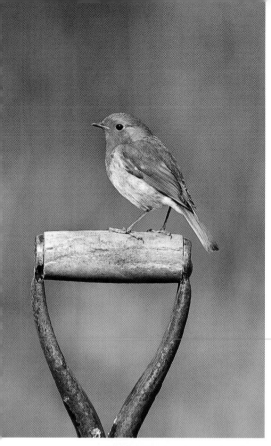

This is a classic shot and one that has been taken many times before: a Robin on a gardener's spade. It was some time before this individual actually landed on the spade. Blue Tit, Great Tit and Long-tailed Tit all came and went before the Robin obliged.

Robin
500mm lens, 1/250sec at f5.6

A perch was placed above the seed scattered on the ground, but this male Brambling just refused to land on it! So, I took some pictures of it on the ground anyway, and accepted the fact that I would have to return another day.

Brambling
500mm lens, 1/125sec f4, Sensia 100 uprated to 200

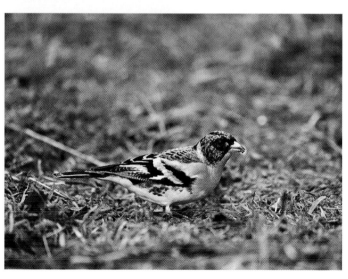

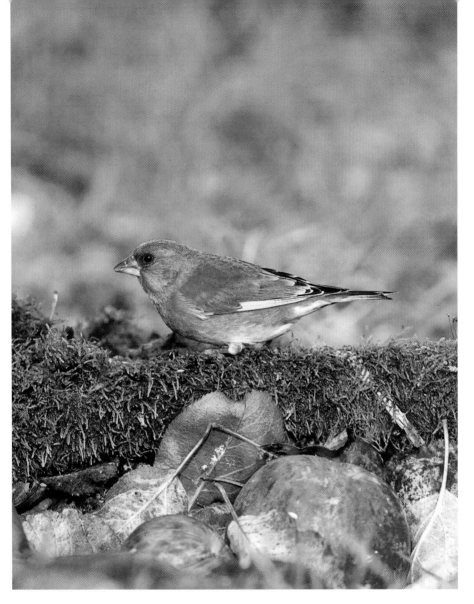

This mossy log was positioned on the ground with seed scattered discreetly behind it. The apples and leaves in the foreground added colour. Many of the birds just dropped straight down onto the seed, but now and then a Greenfinch obligingly landed just where I wanted it to.

Greenfinch
500mm lens, 1/125sec at f4

Other birds

The birds mentioned in this section are intended as a good starting point for your winter photography, but you will find many others in your own locality to photograph, too. If you live near the coast, flocks of gulls can be seen, and Snow Buntings and Shore Larks may be wintering; playing fields, dumping sites and waste ground can provide opportunities for seeing Iceland and Glaucous Gulls, which are always good to get on film. Great Northern and Black-throated Divers, Slavonian and Black-necked Grebes may turn up on lakes or reservoirs. Hard weather in Scandinavia sometimes forces large flocks of Waxwings to move south and they can occur almost anywhere in the UK where berry bushes grow. If you do come across a flock, take lots of film, because while Blue Tits and Robins look nice enough, the appearance of a Waxwing will have you shooting roll after roll.

Spring

In the UK, the first migrants reach shore mid-March and provide the first opportunities to photograph early arrivals such as Northern Wheatear. As the season progresses, the change in climate becomes more noticeable with Common and Sandwich Terns, Swallows, Cuckoos and many other species arriving in numbers.

Photograph visiting birds as soon as possible after they arrive; this is the time when they claim their territories for the breeding season, and the males make their presence felt by singing to attract a mate. Many will have a regular perch, and it is worth thinking ahead and positioning your hide carefully in place to reap the rewards.

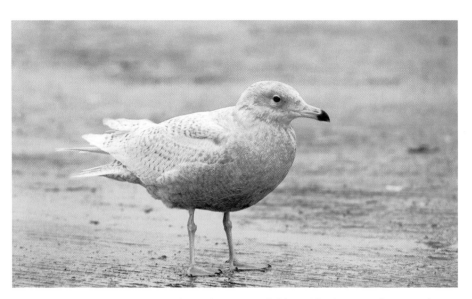

Winter brings many gulls to shorelines, dump sites, fields and harbours, and among them are some more unusual species. This Glaucous Gull was photographed at Lowestoft Harbour in Suffolk, England, on a wet and windy day. A meter reading was taken from a neutral tone on the ground as I felt the bird was too pale to take an accurate reading.

Glaucous Gull
500mm lens, 1/60sec at f4

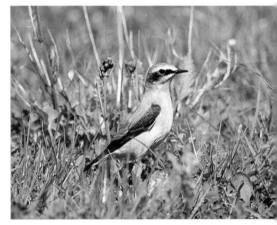

Northern Wheatear is one of the first spring migrants to arrive in Britain, sometimes as early as mid-March. This is a good time to photograph them before they move on to their breeding grounds.

Northern Wheatear
800mm lens, autoexposure

Willow Warblers are synonymous with the spring and can be seen all season. I spot-metered off the bird's mantle for this shot because, at times, it moved into the bush and quite high up against the sky which made it more difficult to meter.

Willow Warbler
800mm lens, 1/125sec at f5.6

The Dotterel is one of my favourite subjects and, on this occasion, one of the closest. This individual was carefully stalked and I was rewarded with a nice series of shots; the bird was so at ease with my presence that it went to sleep in front of me.

Dotterel
600mm lens, 1/125sec at f5.6

Common birds such as Willow Warbler and Chiffchaff can be surprisingly difficult to photograph well. While they can be quite confiding, even without a hide, they move quickly, flitting restlessly from branch to branch. In my role as photographic consultant for *Birdwatch* magazine, these are two species that I find it hard to source when required, and I try every year to build up my library on them.

As mentioned earlier, one of my regular photographic events is the arrival of Little Gulls to my local reserve. This occurs mid-April to early May and, along with Dotterel, is an essential part of my spring photography. These birds breed in the Highlands of Scotland but have regular stopping-off sites around Britain, one of which is at Pendle Hill, Lancashire. Dotterel fall into that category of birds that are few and far between; they can be very tame and, providing care is taken, will allow photographers a close approach. I tend to approach slowly and from the side, rather than head on, making sure the sun is behind me, and move in stages so the bird has time to get used to me. Often, if you are patient enough, the birds will move slowly towards you.

The geese, swans and ducks of winter will be gone by mid-spring. And while the majority of waders that were present in their thousands will also have migrated, there will be a few still around. Birds such as Dunlin will have moulted into breeding plumage by now and look very different from the drab grey tones of winter. Sanderlings are late migrants and will still be on the beaches in mid- to late May, offering good photographic opportunities – but, be quick, they do run very fast.

Swaying reeds providing plenty of cover for a singing bird. With patience, you will find that the bird will show every now and then.

Marsh Warbler
800mm lens, 1/250sec at f5.6

Woodlands and reed beds will be alive with song, but photographing singing birds can be difficult. Birds of the reeds tend to sing profusely, but usually from cover – and with woodland birds, trees also provide lots of cover, hiding potential photographic subjects. A spell of watching your local patches will help you identify the best spots for migrating birds and the best lens suited to the task of capturing them. You may need to erect a hide – or the birds may come close enough to allow a few easy pictures, but it is only by close observation that you will learn these things.

Among the more common migrants that will be moving through at this time of year, will also be a number of scarcer – and even rare – species, such as Hoopoe, Bluethroat, Red-backed Shrike and Red-footed Falcon. Many are blown

The grey and white winter plumage of the Sanderling is transformed to bright colours in the summer. This bird was bathing in a pool, but unfortunately stopped as I approached in the car.

Sanderling
800mm lens, 1/250sec at f5.6

off-course by strong winds, overshoot their intended destination and land instead in Britain. News of such arrivals is available via a number of sources: pagers, birdlines (phone information services) and the Internet.

Many of the birds can be photographed with a long lens and patience, but sometimes their stay is a short one – so you may have to move quickly. In the UK, a weekend break to the Yorkshire or Norfolk coast in the spring can be rewarding, because you just never know what may turn up.

During the early part of spring the feeding station can still be busy with birds, especially if the weather is poor and natural food is in short supply. Numbers will be down compared to the middle of winter but it is always worth spending some time there just to see what is happening.

Summer

Summer is the quietest season in the bird photographer's calendar, and the birds that do remain are not at their best in terms of plumage. All birds undergo several moults, and summer is the worst time for many species, especially ducks. The males completely lose all the colourful breeding plumage and become a ragbag of browns and blotchy greys. But this in itself is worth photographing in order to build up a complete record of the bird's plumage. If you have difficulty finding ducks locally, then a visit to local WWT or lakes and reservoirs will offer opportunities for photography. Teeming with wild birds in the winter, they are virtually deserted throughout the summer, but ducks and other species can be seen. True, they are not wild and the sense of excitement is not quite the same, but it is still good practice for your photography and the pictures may come in useful, so don't be put off.

By comparison, more exciting is a visit to a seabird colony – lots of birds, noise and action. There are many mainland colonies to visit, but some of the most atmospheric are to be found off British shores, many with public access – and these are superb for a photographic day out. By way of an example, the Farne Islands off the Northumberland coast in Northeast England is a very good spot for this type of bird photography.

A trip to the Farne Islands

Taking one of the regular boat trips from Seahouses in the Farne Islands, the first stop is Staple Island where Puffins

greet you as you walk along the landing stage. Frame-filling shots can be taken using a 500mm lens, as these comical birds are unafraid of human visitors. Try using a smaller lens for some group shots and scenic views that include the Puffins in the foreground. At this site, the pathways are clearly marked with ropes put up to prevent visitors walking on the burrows used by the birds for nesting. Shags, Fulmars, Kittiwakes, groups of Guillemots and Razorbills can also be photographed and add to the atmosphere.

Next stop is Inner Farne, and the welcoming committee are the Arctic Terns that dive-bomb you as you leave the boat – not as friendly a greeting as we were given by the Puffins. The terns nest all over the island and can pose beautifully for photos sitting on walls and fences. The much rarer Roseate Tern can be seen here, although it is more difficult to photograph, but the ever-present Puffins offer themselves for endless posing.

There are many other seabird colonies around the world, but whichever one you choose to visit, remember to take plenty of film – there is so much going on, you will be amazed at how quickly you use up the rolls.

The summer months provide the only time to take photographs of young birds, which often look really quite different from the adults. This is especially important for taking year-long records of a specific species; it's the only time you have the opportunity to get a picture of the young. Juvenile Robins, for example, look quite dissimilar to their parents, but soon change and start to develop the red breast.

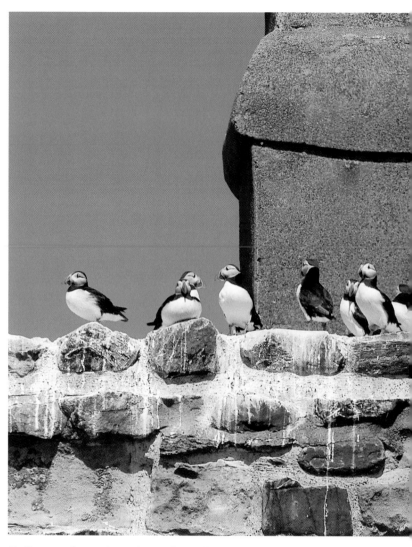

Puffins are the perfect subjects for a photographic day out. They gather in profusion on their breeding sites, and they are tame and very photogenic. Try to take a variety of shots with different lenses and in varying poses.

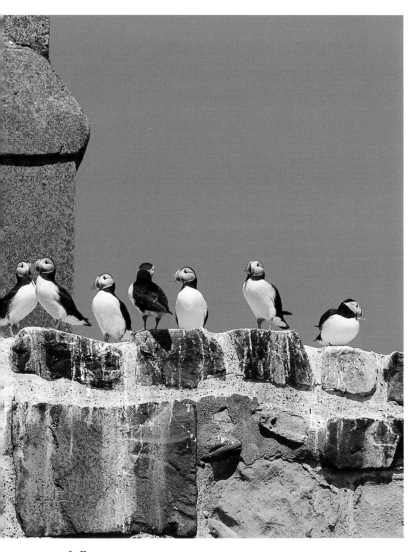

Puffins

70–300mm zoom lens at 300mm setting, 1/250sec at f8

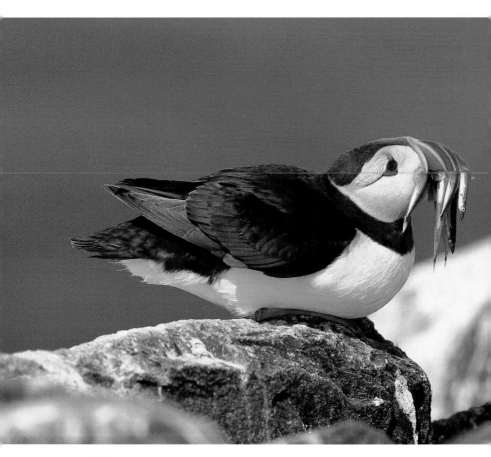

Puffin

500mm lens, 1/250sec at f8

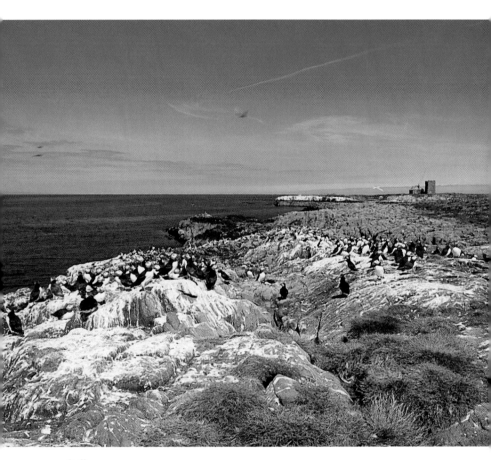

Puffins

24mm lens, 1/60sec at f8

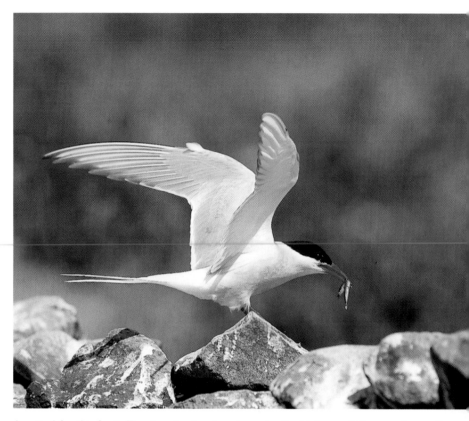

I waited for this Arctic Tern to raise its wings to make the picture a little more interesting. Underexposing slightly has enabled me to get some feather detail in the wings.

Arctic Tern
500mm lens, 1/250sec at f8

Right *Probably the easiest of the Farne Island birds to photograph, the Shags just sit amiably along the island paths and look at you. Exposing for the mid-tones of the nest has enabled me to produce reasonable detail in the bird's black plumage.*

Shag
70–300mm zoom lens at 100mm setting, 1/125sec at f8

Late summer is the start of migration for many species.
In recent years, there has been a growth in the popularity
of pelagic trips to watch the movement of skuas and petrel
species at sea. The best ones for photography are on the
smaller boats, which can stop or follow the birds. If you
are lucky, you may capture close-up views of species that
are difficult to photograph – Storm Petrel, Sabine's Gull,
Great Shearwater and the Wilson's Petrel, which is rare.
The movement of the boat can sometimes handicap your
picture-taking, making a tripod absolutely redundant, and
can make you feel seasick, which, believe me, is a bad
experience. Everything has to be hand-held, so use the
fastest shutter speed possible and take lots of shots to
ensure that one or two may be good enough.

Autumn

As far as the birds are concerned, the return of colder weather
brings with it huge migrations from the breeding grounds.
From mid-September onwards, wildfowl start to return to their
regular haunts, while the flocks of Dunlin and Knot once again
build up on the estuaries.

Sea-watching from coastal headlands is at a peak during
the autumn. It is not easy; the inclement weather forces the
petrels and skuas inshore, and does not offer the best
conditions for taking pictures. However, with a waterproof
cover on the lens (and one on you, too) it is possible. Do try
to avoid salt spray on the equipment, too, which will not do
it any good at all.

Autumn is prime time for rare migrants to be blown off course to the British Isles, especially much sought-after American birds. I regularly spend two weeks on the Isles of Scilly during October, but so do hundreds of other birdwatchers and photographers. If you don't like crowds and sharing your birds, it is probably better to leave Scilly – and maybe even rare bird photography – alone. But Scilly does provide opportunities to photograph species that you are unlikely to be able to otherwise, unless you can travel the world in pursuit of them, which is not always possible. I think just for a short period, it is worth making the extra effort and putting up with the crowds to photograph scarce birds such as Wryneck, Bluethroat and Common Rosefinch. There are plenty of birds to photograph, and it is quite something to know that you are among the few to photograph a first for British shores.

Away from the rarities, the feeding station will be active again, and it will be time to sort out some new perches to replace last season's old ones. Remember to do this, otherwise your photographs will contain birds all sitting on the same ones, which can look quite odd when showing off your slides to other people.

Many waders, such as Little Stint, Dunlin and Curlew Sandpiper, can be tame and photographed without a hide, depending on the accessibility of the locality.

With November melting into December, thus the photographer's year turns full circle, inspiring him or her to capture on film the birds that were missed through the year in the twelve months to come.

Autumn waders are often juveniles, and this Greenshank posed beautifully while feeding. Taken on the Isles of Scilly from a public hide.

Greenshank
500mm lens, 1/500sec at f5.6

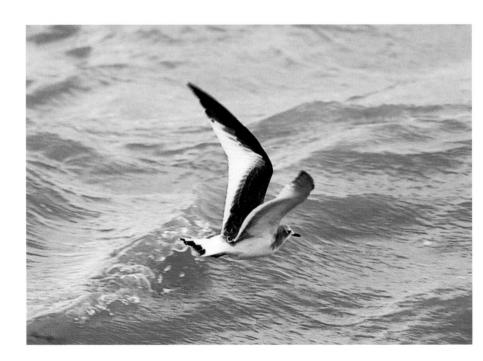

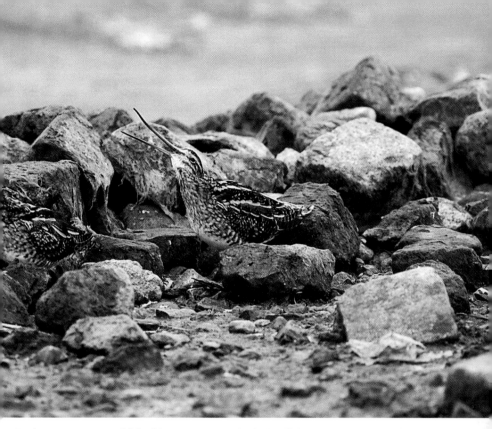

Luck or perseverance? I had been sitting in the hide all day in overcast weather and just thought I'd take a shot of these roosting Snipe to keep myself occupied. I'd taken one or two and was about to stop when one of the birds lifted its head, stretched and opened its bill. It was all over in a couple of seconds and I only managed two shots, one of which was sharp. You never know when you are going to get lucky – and that is part of what makes this hobby so absorbing and addictive.

Common Snipe
800mm lens, 1/125sec at f5.6

Left **A gale-force seven wind and driving rain with salt spray are not ideal conditions to attempt a photograph of a fast-flying gull. But since it is only this type of weather that brings the species close inshore, you just have to try. From two rolls of film, four shots were acceptable.**

Sabine's Gull
500mm lens hand-held, 1/500sec at f4

Bird photography notebook

Date	Camera	Lens	Film	Shutter Speed	Apert
Feb 19th	Nikon F 5	500mm AF	2 rolls Fujichrome 100	1/250th	f5.6

e of Metering	Species	Result	Other Notes
entre-weighted	G.S. Woodpecker	Generally good	Exposures accurate; good light today; used manual focus; lots of spoilt shots with bird jerking head!

Date	Camera	Lens	Film	Shutter Speed	Apertu

e of Metering	Species	Result	Other Notes

About the author

Widely acknowledged as one of the UK's top bird photographers, Steve is a regular columnist for *Birdwatch* and *Outdoor Photography* magazines.

Inspired by Eric Hosking's book *An Eye for a Bird*, he took up bird photography in the 1970s. After working for the Post Office for twenty years, he decided to leave in 1992 to make photography his full-time career. His photographs have appeared in a wide variety of books and magazines and, in 1999, he won the Carl Zeiss Award with a shot of a Pallid Swift, deemed to be the most useful rarity identification photo of the year.

Steve's first ventures into book publishing were as photographic editor for two handbooks on bird photography: *Wildfowl of the World* and *Rare Birds of Britain and Europe*. Now an established author, Steve's previous titles include *Birds on Film* (Hobby Publications) and *An Essential Guide to Bird Photography*, also published by GMC Publications Ltd in 2001.

Index

Page numbers in **bold** refer to captions of bird photographs.

WOODCARVING

Beginning Woodcarving	GMC Publications
Carving Architectural Detail in Wood: The Classical Tradition	Frederick Wilbur
Carving Birds & Beasts	GMC Publications
Carving the Human Figure: Studies in Wood and Stone	Dick Onians
Carving Nature: Wildlife Studies in Wood	Frank Fox-Wilson
Carving on Turning	Chris Pye
Decorative Woodcarving	Jeremy Williams
Elements of Woodcarving	Chris Pye
Essential Woodcarving Techniques	Dick Onians
Lettercarving in Wood: A Practical Course	Chris Pye
Making & Using Working Drawings for Realistic Model Animals	Basil F. Fordham
Power Tools for Woodcarving	David Tippey
Relief Carving in Wood: A Practical Introduction	Chris Pye
Understanding Woodcarving in the Round	GMC Publications
Useful Techniques for Woodcarvers	GMC Publications
Woodcarving: A Foundation Course	Zoë Gertner
Woodcarving for Beginners	GMC Publications
Woodcarving Tools, Materials & Equipment (New Edition in 2 vols.)	Chris Pye

WOODTURNING

Adventures in Woodturning	David Springett
Bert Marsh: Woodturner	Bert Marsh
Bowl Turning Techniques Masterclass	Tony Boase
Chris Child's Projects for Woodturners	Chris Child
Colouring Techniques for Woodturners	Jan Sanders
Contemporary Turned Wood: New Perspectives in a Rich Tradition	Ray Leier, Jan Peters & Kevin Wallace
The Craftsman Woodturner	Peter Child
Decorating Turned Wood: The Maker's Eye	Liz & Michael O'Donnell
Decorative Techniques for Woodturners	Hilary Bowen
Illustrated Woodturning Techniques	John Hunnex
Intermediate Woodturning Projects	GMC Publications
Keith Rowley's Woodturning Projects	Keith Rowley
Making Screw Threads in Wood	Fred Holder
Turned Boxes: 50 Designs	Chris Stott
Turning Green Wood	Michael O'Donnell
Turning Pens and Pencils	Kip Christensen & Rex Burningham
Useful Woodturning Projects	GMC Publications
Woodturning: Bowls, Platters, Hollow Forms, Vases, Vessels, Bottles, Flasks, Tankards, Plates	GMC Publications
Woodturning: A Foundation Course (New Edition)	Keith Rowley
Woodturning: A Fresh Approach	Robert Chapman
Woodturning: An Individual Approach	Dave Regester
Woodturning: A Source Book of Shapes	John Hunnex
Woodturning Jewellery	Hilary Bowen
Woodturning Masterclass	Tony Boase
Woodturning Techniques	GMC Publications

CRAFTS

American Patchwork Designs in Needlepoint	Melanie Tacon
A Beginners' Guide to Rubber Stamping	Brenda Hunt
Beginning Picture Marquetry	Lawrence Threadgold
Blackwork: A New Approach	Brenda Day
Celtic Cross Stitch Designs	Carol Phillipson
Celtic Knotwork Designs	Sheila Sturrock
Celtic Knotwork Handbook	Sheila Sturrock
Celtic Spirals and Other Designs	Sheila Sturrock
Complete Pyrography	Stephen Poole
Creative Backstitch	Helen Hall
Creative Embroidery Techniques Using Colour Through Gold	Daphne J. Ashby & Jackie Woolsey
The Creative Quilter: Techniques and Projects	Pauline Brown
Cross-Stitch Designs from China	Carol Phillipson
Decoration on Fabric: A Sourcebook of Ideas	Pauline Brown
Decorative Beaded Purses	Enid Taylor
Designing and Making Cards	Glennis Gilruth
Glass Engraving Pattern Book	John Everett
Glass Painting	Emma Sedman
Handcrafted Rugs	Sandra Hardy
How to Arrange Flowers: A Japanese Approach to English Design	Taeko Marvelly
How to Make First-Class Cards	Debbie Brown
An Introduction to Crewel Embroidery	Mave Glenny
Making and Using Working Drawings for Realistic Model Animals	Basil F. Fordham
Making Character Bears	Valerie Tyler
Making Decorative Screens	Amanda Howes
Making Fabergé-Style Eggs	Denise Hopper
Making Fairies and Fantastical Creatures	Julie Sharp
Making Greetings Cards for Beginners	Pat Sutherland
Making Hand-Sewn Boxes: Techniques and Projects	Jackie Woolsey
Making Knitwear Fit	Pat Ashforth & Steve Plummer
Making Mini Cards, Gift Tags & Invitations	Glennis Gilruth
Making Soft-Bodied Dough Characters	Patricia Hughes
Natural Ideas for Christmas: Fantastic Decorations to Make	Josie Cameron-Ashcroft & Carol Cox
New Ideas for Crochet: Stylish Projects for the Home	Darsha Capaldi
Papercraft Projects for Special Occasions	Sine Chesterman
Patchwork for Beginners	Pauline Brown
Pyrography Designs	Norma Gregory
Pyrography Handbook (Practical Crafts)	Stephen Poole
Rose Windows for Quilters	Angela Besley
Rubber Stamping with Other Crafts	Lynne Garner
Sponge Painting	Ann Rooney

MAGAZINES

WOODTURNING ◆ WOODCARVING ◆ FURNITURE & CABINETMAKING
THE ROUTER ◆ WOODWORKING ◆ THE DOLLS' HOUSE MAGAZINE
OUTDOOR PHOTOGRAPHY ◆ BLACK & WHITE PHOTOGRAPHY
TRAVEL PHOTOGRAPHY ◆ MACHINE KNITTING NEWS
BUSINESSMATTERS

The above represents a full list of all titles currently published or scheduled to be published.
All are available direct from the Publishers or through bookshops, newsagents and specialist retailers.
To place an order, or to obtain a complete catalogue, contact:

GMC Publications,
Castle Place, 166 High Street, Lewes, East Sussex BN7 1XU, UK
Tel: 01273 488005 Fax: 01273 478606
E-mail: pubs@thegmcgroup.com

Orders by credit card are accepted